*How to Draw*
# CHARCOAL, SANGUINE, AND CHALK

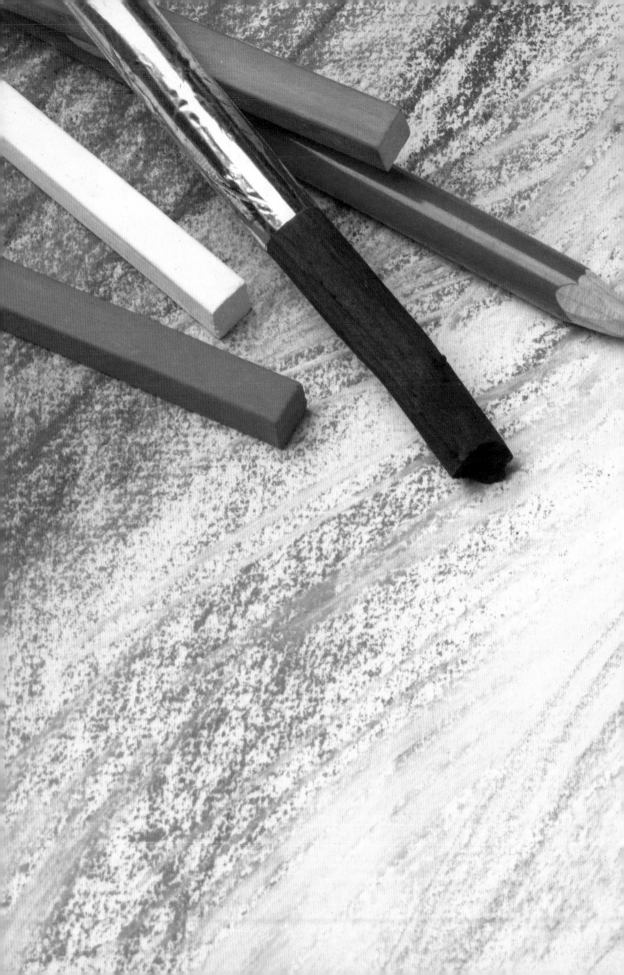

# How to Draw with
# CHARCOAL, SANGUINE, AND CHALK

### José M. Parramón

*Watson Guptill Publications/New York*

Copyright © 1989 by Parramón Ediciones, S.A.
Published in 1989 in Spain by Parramón Ediciones, S.A.,
Barcelona.

First published in 1990 in the United States by Watson-Guptill
Publications, a division of Billboard Publications, Inc.,
1515 Broadway, New York, N. Y. 10036.

**Library of Congress Cataloging-in-Publication Data**

Parramón, José María.
   [Cómo dibujar al carbón, sanguina y cretas. English]
   How to draw with charcoal, sanguine, and chalk / José M. Parramón.
      p.    cm.—(Watson-Guptill artist's library)
   Translation of: Cómo dibujar al carbón, sanguina y cretas.
   ISBN: 0-8230-2368-0
      1. Drawing—Technique. 2. Charcoal drawing—Technique. I. Title.
   II. Series.
   NC845. P3713 1990
   741.2—dc20                                              89-46710
                                                              CIP

Distributed in the United Kingdom by Phaidon Press Ltd.,
Musterlin House, Jordan Hill Road, Oxford OX2 8DP.

Manufactured in Spain
Legal Deposit: B-45.240-89

**1 2 3 4 5 6 7 8 9 10 / 94 93 92 91 90**

# Contents

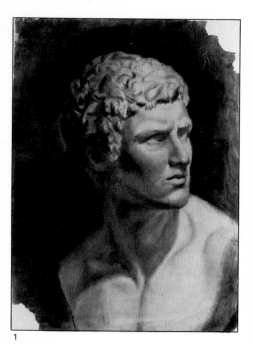

1

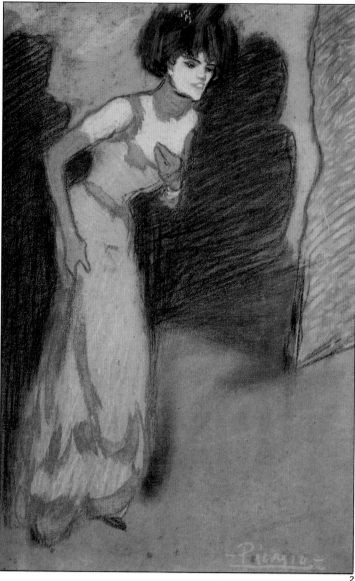

2

Figs. 1 and 2. Pablo Picasso (1881-1973), *Academic Study*, charcoal, and *Singer Taking a Bow*, pastel, Picasso Museum, Barcelona. Two drawings from Picasso's early period: the first, a plaster cast (or classical sculpture reproduced in plaster for use as a model), and the second, a pastel sketch.

# Introduction

## Picasso's lesson

In an old district of the city of Barcelona, located at No. 7, Condes de Montcada Street, in a magnificent 16th-century Gothic palace, there is one of Europe's most important museums of drawing and painting, which is visited by an average of 1,500 people every day: the Picasso Museum, famous for its collection of over 300 early works by Picasso. These date from his days as a fine arts student (between the ages of 11 and 15) to the time of his first trip to Paris (at the age of 19) in the fall of 1900.

In the museum's room devoted to "The early drawings at the *Lonja*" (Lonja is the old building of the School of Fine Arts in Barcelona), the visitor may be surprised to see an academic drawing of a plaster cast executed in charcoal. In one of the adjoining rooms, the visitor may be even more surprised by a selection of drawings and sketches for which Picasso chose to use chalks and pastels. Indeed, after seeing his early art school drawings, whose perfection and style belong to the best academic tradition, it is not surprising to see how only four years later Picasso's drawings and sketches reveal the art and synthesis of a true master.

Picasso drew hundreds, perhaps thousands, of these sketches. His notebooks, small pocket books measuring no more than 6 1/3 × 4 3/4 in. (16 × 12 cm) are famous. Besides shopping lists and other personal jottings, Picasso filled the pages of these notebooks with human figure drawings, quick sketches of men and women that, as Picasso himself said, were intented to capture and express the essence of everyday life.

The Picasso Museum is an ideal place to learn and understand what school and path one should follow in order to draw and paint as an artist. That is, begin with drawings of plaster casts like Picasso, use charcoal and charcoal pencil to sketch the original in black and white, learn to construct, to form "carefully considered strokes," and to calculate dimensions and proportions. Learn also how to solve the problems of light and shadow, to create value by suggesting volume. Then execute more drawings "painted" with combined techniques—charcoal, sanguine, and chalk on colored paper enhanced with white chalk—which slowly but surely, through the knowledge and practice of the art of painting, lead to a progressive understanding of color. That is the philosophy behind this book. After a thorough study of the materials—charcoal, charcoal pencils, sanguine, chalks, stumps, erasers, and so forth—the techniques and possibilities of each medium are discussed, together with examples by the great masters. The book also contains a series of exercises with step-by-step demonstrations, beginning with a charcoal drawing from a plaster cast—the half mask of Beethoven—followed by sanguine and chalk drawings, using the solutions and finishing touches derived from the art of drawing, and ending with combined techniques in which color finally predominates.

We may not reach the heights of Picasso, but we will follow his example and his method for learning to draw and paint. With this aim in mind, I wish you good luck and good drawing.

**José M. Parramón**

Drawing and painting materials have remained virtually unchanged for the last 200 or 300 years: Charcoal dates back to prehistoric times, chalks and sanguines appear around 1500, and the lead graphite pencil was first manufactured in 1640. However, there have been some important changes over recent years: Charcoal sticks are available in different degrees of hardness; in addition to the traditional compressed charcoal pencil, there are also related products made of natural or artificial charcoal; as for chalks and sanguines, manufacturers produce sets of special color ranges as well as sanguine pencils, white chalk pencils, crayons, and leads; finally, there are now kneadable or pliable erasers.

All these and other materials used in charcoal, sanguine, and chalk drawing will be discussed in this chapter.

3

# MATERIALS

# Charcoal

Charcoal is made of carefully selected, knot-free twigs of oak, willow, briar, or any other light, porous wood that has been partially burnt and carbonized and then converted into bars of fine, natural drawing charcoal. Charcoal comes in 5- or 6-in. (13- or 15-cm) sticks, with a diameter ranging from 1/5 to 1/2 in. (5 mm to 1.5 cm). Most manufacturers produce three degrees of hardness: soft, medium, and hard.

The process of selection and carbonization is vital in the production of good quality charcoal, which must be free of any knots or tiny crystallized particles, since these could scratch the fiber of the paper.

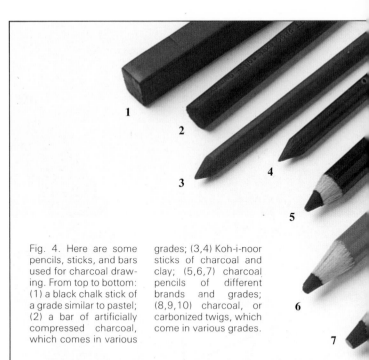

Fig. 4. Here are some pencils, sticks, and bars used for charcoal drawing. From top to bottom: (1) a black chalk stick of a grade similar to pastel; (2) a bar of artificially compressed charcoal, which comes in various grades; (3,4) Koh-i-noor sticks of charcoal and clay; (5,6,7) charcoal pencils of different brands and grades; (8,9,10) charcoal, or carbonized twigs, which come in various grades.

## MAJOR BRANDS OF CHARCOAL

| Brand | Extra Soft | Soft | Medium | Hard |
|---|---|---|---|---|
| Conté | | 3B | 2B | B | HB |
| Faber-Castell "Pitt" | | Soft | Medium | Hard |
| Koh-i-noor "Black" | 1, 2 | 3, 4 | 5 | 6 |
| Staedtler "Carbonit" | 4 | 3 | 2 | 1 |

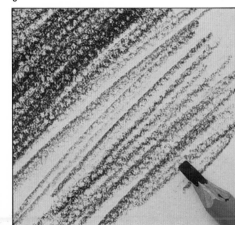

Figs. 5 and 6. Charcoal on white Ingres paper and charcoal pencil on Canson Mi-Teintes paper.

# The compressed charcoal pencil and its derivatives

8

9

10

The compressed charcoal pencil was invented in the last century by the Parisian manufacturer Conté. That is why all subsequent pencils of this kind have been known as "Conté pencils or sticks."

Generally, all good manufacturers of lead pencils also make compressed charcoal lead pencils. These include Conté, Faber, Koh-i-noor, and Staedtler.

Most of these manufacturers also produce bars and sticks of charcoal and charcoal pencil, made of natural or artificially compressed charcoal. In some cases the charcoal has been mixed with clay and binders added, thereby giving these products the stability of charcoal pencil and the strength and smoothness of pastels. There are also cylinder-shaped leads made with clay that produce an intense black, as well as bars and sticks of chalk, all of which produce excellent results in charcoal drawing.

Finally, there is a substance called "powdered charcoal," which may be combined with chalks or pressed charcoal by blending with a stump or with the fingers. Drawings in charcoal, charcoal pencil, or any materials derived from them in the form of sticks, bars, or chalk must be fixed with a fixative liquid.

8

Figs. 7 and 8. Powdered charcoal is a useful pigment in drawing. By applying it to the paper and then blending it, powdered charcoal can be used for shading and building up values.

# Examples of charcoal and charcoal pencil drawings

Portraits, human figures, nudes, landscapes, still lifes—they all make good subjects for charcoal or charcoal pencil drawing. Down through the ages, artists have used this medium for making studies of their subjects and for solving problems of light and contrast, for studies of the human figure, principally the nude, for drafts and "cartoons" (small-scale sketches for murals or large paintings), and even for preliminary sketches for oil paintings, a method still used today by many professional artists. Two representative examples are reproduced on this page: a portrait in charcoal by Ramón Casas, a famous artist who drew dozens of portraits in charcoal, and a landscape of the Grand Canal in Venice, which I drew with charcoal.

One the next page, there are two studies of a nude and a still life drawn in charcoal, the medium normally used for this kind of work.

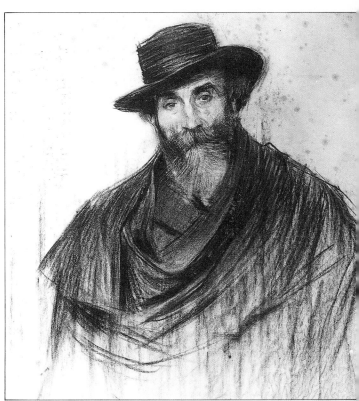

10                                                          9

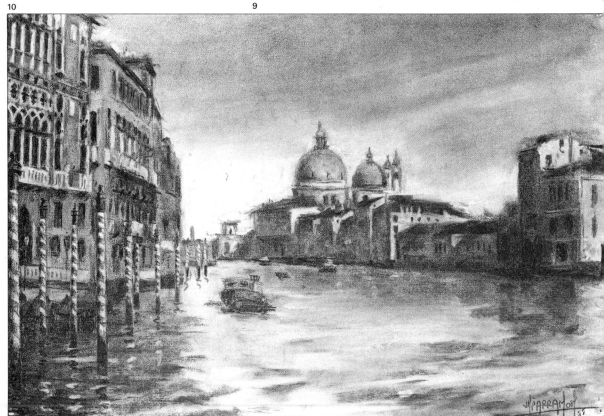

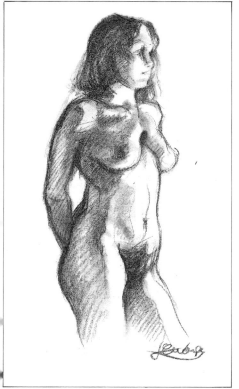

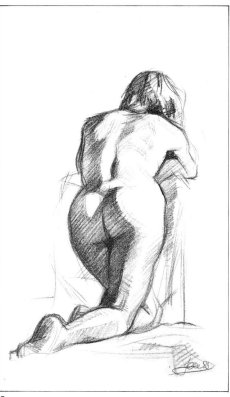

Fig. 9. Ramón Casas, portrait in charcoal, Museum of Modern Art, Barcelona. A good example of the possibilities of charcoal for human figure and portrait drawing.

Fig. 10. J.M. Parramón, *The Grand Canal in Venice*. I drew this subject in charcoal with the help of a pliable eraser, a material I will discuss a little later in this book.

11

12

13

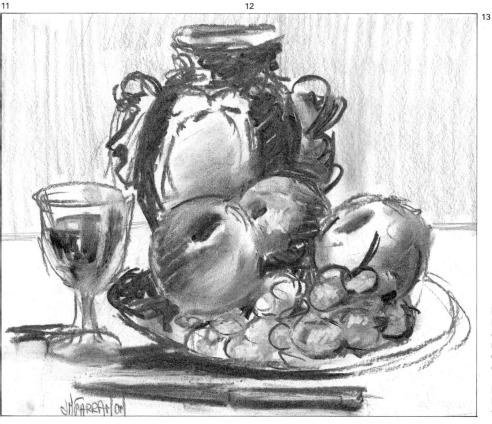

Figs. 11 and 12. Miquel Ferrón, lecturer in fine arts and a good friend of mine, did these sketches of a nude from life in charcoal.

Fig. 13. Finally, a still life I drew in charcoal on very fine-grain paper.

# Chalks, sanguines, and pastels

Chalk is a kind of soft limestone of or- 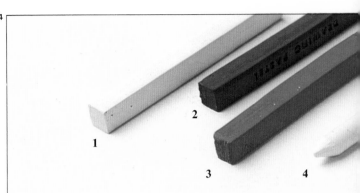 ganic origin that is colored white or gray and that, when mixed with water and a binder, produces the chalk sticks and pencils that we use for enhancing a drawing on colored paper. White chalk was first used by such artists as Botticelli, Perugino, and Verrocchio in their early metalpoint drawings on colored paper. At the beginning of the 16th century, Leonardo da Vinci mixed iron oxide with chalk and so introduced the technique of sanguine drawing. By the last few decades of the 17th century, chalks were available in sanguine, dark sienna, black, gray, ochre, and ultramarine blue. Pastels first made their appearance at the beginning of the 16th century. They have a consistency similar to chalk, but with one fundamental difference: Chalk is a hard material, while pastel is an extremely soft medium. By the end of the 19th century, there were also hard pastels, which were used to great effect by Degas.

Nowadays, there is practically no difference between chalks and some brands of pastels; Koh-i-noor supplies loose bars and sticks of white chalk, sanguine, sienna, black, as well as sets of twelve colored chalks. These Koh-i-noor chalks have the same degree of hardness as hard-grade pastels manufactured by Faber-Castell, which come in boxes of seventy-two colors. In addition to the seventy-two colors, Faber also produces twelve-stick boxes containing six shades of gray and another containing shades of sanguine. The last is designed for *le dessin à trois crayons,* as it was called in the 18th century by Watteau, Fragonard, and Boucher, that is, the technique of drawing combining black, sanguine, and white chalk on colored paper. We will discuss this technique in the following pages.

Fig. 14. Chalks in the form of bars, sticks, and pencils for drawing and painting. From top to bottom, (1, 2, 3) soft-grade chalk in white, sienna, and sanguine; (4, 5) hard-grade Koh-i-noor sticks in white and sanguine; (6, 7, 8, 9) pastel pencils.

Fig. 15. Sets of colored chalks: the upper two boxes are by Faber-Castell, the first containing a selection of ochre and sanguine colors, plus white; and the second, a selection of grays, plus white and black.

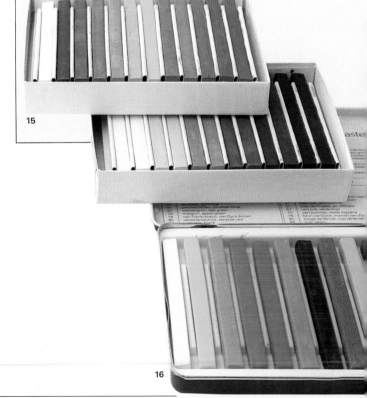

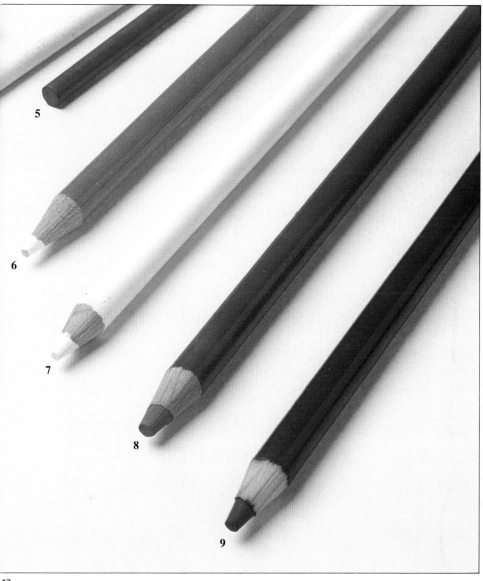

5

6

7

8

9

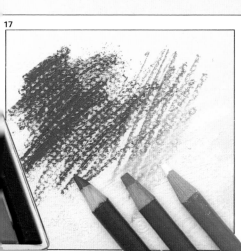

17

Fig. 16. Left, a selection box by Faber-Castell. Both Faber and Koh-i-noor color selections are taken from these manufacturers' complete pastel ranges. It is now impossible to distinguish colored chalks from pastels in regard to their gradations or degrees of hardness. However, there are brands of pastels softer than those we have mentioned.

Fig. 17. Fine detail in *dessin à trois crayons* on cream-colored paper is a much easier and more comfortable task thanks to the availability of sienna, sanguine, white, and colored chalks in pencil form.

# Some examples of combined techniques

Fig. 18. Peter Paul Rubens (1577-1640), *Young Woman with Hands Folded* (detail), black chalk, charcoal, and sanguine, enhanced with white chalk on cream-colored paper, Boymans-Van Beuningen Museum, Rotterdam. This magnificent drawing by Rubens perfectly illustrates the combined technique: using black chalk, red sanguine, white chalk, and the cream-colored background of the paper.

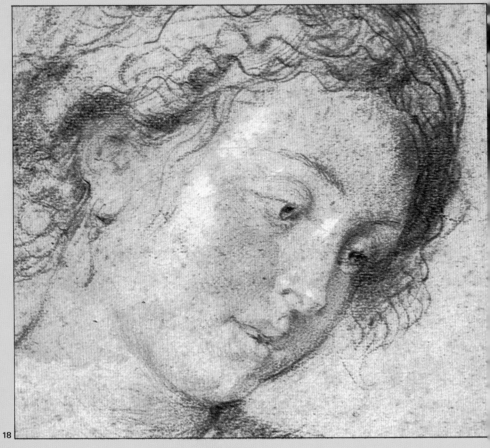

**18**

**19**

Fig. 19. Jean-Antoine Watteau (1684-1721), *Study of a Nude* (detail), sanguine and black chalk on cream-colored paper, Cabinet des Dessins, Louvre, Paris. The *dessins à trois crayons* is a perfect combination for rendering the color of the flesh. By using sanguine with black chalk or charcoal pencil, together with the color of the paper, it is possible to achieve flesh tones in pink, sienna, dark brown, and black.

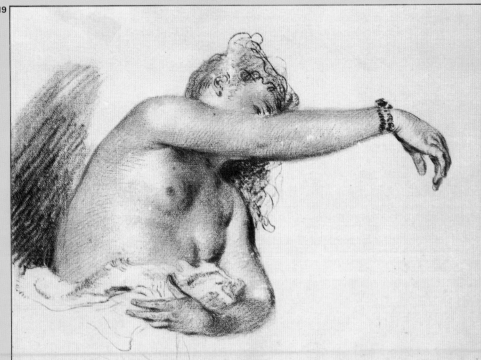

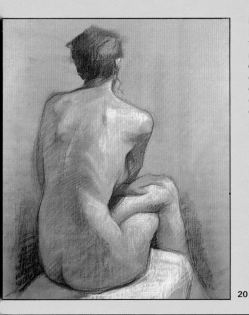

Fig. 20. In this drawing Miquel Ferrón builds up the body and color of the model on a background of sienna-colored paper, combining sienna, sanguine, black, and white chalks, to produce an excellent overall effect.

20

21

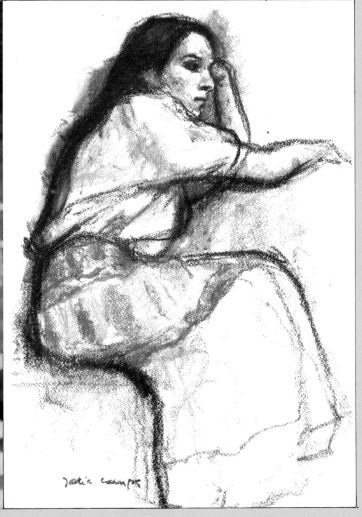

Fig. 21. In this modern drawing, the artist Badía Camps gives us a wonderful example of how pastels can be used to "paint" a drawing. Notice how color is used to complement the drawing, the structure and value being achieved with black chalk, dark sienna, and warm gray.

# Stumps

As you know, stumps are long, cylinder-shaped drawing tools made of porous paper with a point at each end. The stump is used for blending, rubbing, and creating value in lines and shaded areas drawn with lead pencil, charcoal pencil, sanguine, chalks, or pastels.

Stumps come in a variety of thicknesses. It is a good idea to use two or three different stumps—fine, medium, and thick—and to keep separate stumps for blending charcoal and colored chalks. Keep one end for light tones and the other for darker tones.

When a stump becomes blunt, all you need to do is sharpen the point with a piece of very fine sandpaper or a blade. Fine detail work on some drawings may require a stump with a point as sharp as a pencil's. In this case you can make your own stump by following the instructions below.

22

**How to make a stump**

Take a piece of paper and cut it according to the shape and measurements shown in Fig. 23. Begin rolling from the corner as in Fig. 24; then roll it between the tips of your thumb and index finger, moistening them to make the process easier (Fig. 25). With the help of the thumb and index finger of your other hand, continue as if you were rolling a cigarette, working the stump into a fine point (Fig. 26 and 27).

Finally, secure the rolled paper with a piece of adhesive tape (Fig. 28).

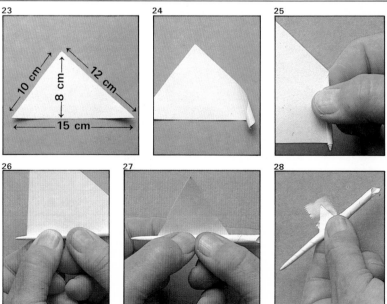

# Fingertip blending

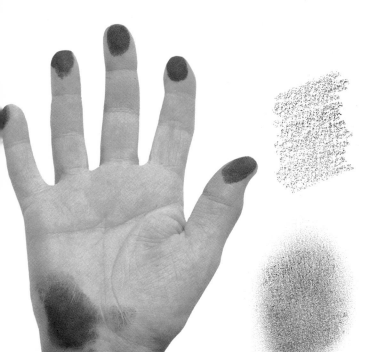

I expect you also know that the fingers, the fingertips, and even the lower part of the palm are extremely efficient and useful means for blending, intensifying, and giving value to drawings. They all perform these tasks as well as, if not better than, the best stumps.

A stump is sharper, but this advantage is offset by the moisture and warmth of the fingers, which help blend and intensify color and tone. Moreover, the fingers can more directly express the artist's desire to lighten or darken the drawing.

29

30

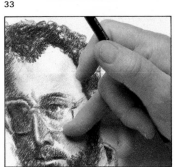

31

32

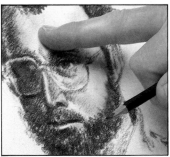

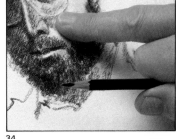

33

34

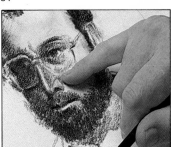

35

36

Fig. 22 (previous page). Here you can see stumps of different thicknesses, including a handmade stump (far left) for blending very small areas. You should keep a separate stump for each color, using one end for dark tones and the other for light tones.

Fig. 29. The fingertips are excellent for blending, while the lower part of the palm is especially good for working over large areas.

Fig. 30. In this illustration compare the grays obtained with a lead pencil (above) with the quality and harmony of the same grays when blended with the fingertips (below).

Figs. 31 to 36. All the fingers of the hand may be used in fingertip blending (Figs. 31, 32, and 34), as well as the sides of the fingers and the edges of the fingertips for working in small areas (Figs. 33, 35, and 36). As you can see in these illustrations, fingertip blending is carried out simultaneously with drawing. With the pencil still in the artist's hand, he blends now with the thumb, now with the index finger, with the middle finger, and occasionally with the ring finger or with the edge of the little finger.

# The common rubber eraser, the pliable eraser... and a rag

If you take a small piece of soft bread and knead it with a few drops of water between your fingers for a while, you will obtain a soft, compact substance that, when applied by pressing gently —without rubbing— to an area of shading drawn with a lead or charcoal pencil, partly erases it, thereby reducing its intensity. This is the primitive eraser used by the old masters from the 15th century throughout the Renaissance until the middle of the 18th century, when Magellan invented the rubber eraser, which was recently perfected in the form of the plastic eraser.

Both rubber erasers and the more modern plastic erasers are suitable for rubbing out lead pencil, carbon pencil, sanguine, and so on. However, in some cases, they are not the best for drawing.

*Drawing* with an eraser? Yes, in a lead or charcoal pencil drawing that has various tones of gray, a portrait, for example, the artist can achieve luster or highlights with an eraser (Figs. 40 and 41). To draw with an ordinary rubber or plastic eraser, you must first cut it on a slant to make a sharp point as if it were a pencil. However, this is not a very convenient method and also ruins the eraser.

This is where the kneadable eraser comes in. With a consistency similar to that of plasticine, it can be molded into any shape, making it suitable for drawing. By means of rubbing out or "opening up" shaded areas, the eraser can be used for drawing points, lines, a star shape, the highlights on buildings in the sunshine, and so forth. (On pages 42 and 43, we will take a practical look at the special technique involved in using the kneadable eraser.

## ... and a rag

An ordinary, clean cotton cloth is an ideal means for drawing by rubbing out charcoals and pastels. We will also devote some space to this technique in the following pages.

Figs. 37 and 38. To pick out a line or stroke on a gray or black background, you can use either an ordinary rubber eraser or a kneadable eraser, but the former (Fig. 37) must be cut to a point, while the latter (Fig. 38), being pliable, can be molded and adapted to the required shape.

Fig. 39. The eraser can be used for drawing a star shape, a letter, or a stroke on a more-or-less gray background.

Figs. 40 and 41. The eraser is a good way of opening up white areas in a drawing done in charcoal pencil, sanguine, or colored chalks, as you can see from this drawing before and after using the eraser.

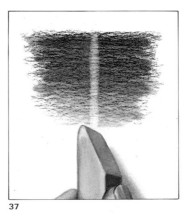

37

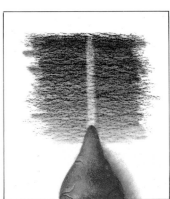

38

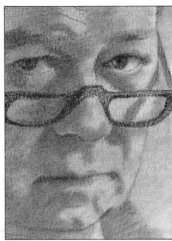

39

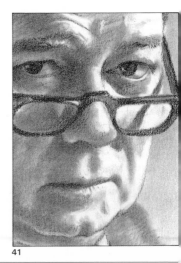

40

41

# Drawing papers

Figs. 42 to 45. Four qualities of drawing paper suitable for charcoal or pastels: woven Ingres paper (Fig. 42); medium-grain D'Arches paper (Fig. 43); Canson Mi-Teintes cream-colored paper (Fig. 44); and a woven colored paper by Fabriano (Fig. 45).

With the exception of glossy, satin-finish paper, such as *papier couché,* all types of drawing paper are suitable for drawing in charcoal, charcoal pencil, sanguine, or pastels. Even very smooth paper, such as Bristol, can give an interesting style or finish to the drawing.

However, the ideal paper for drawing in charcoal, charcoal pencil, or colored chalks is medium-grain paper, such as Canson's Dessin J.A. or Canson's "C" A grain; alternatively, the coarser-grain papers, such as Canson's white Mi-Teintes or woven Ingres paper, are best for larger studies, sketches, or drawings.

**Woven Ingres paper**
Woven Ingres paper is specially designed for charcoal drawing and is commonly used in all fine arts schools and academies for medium-sized to large, full-sheet studies and drawings. It is distinguished by its special weave, a kind of watermark in the form of parallel grooves, which is visible when held up to the light. This special texture shows through the lighter shading of the finished drawing. Some good quality wrapping papers also have laid or woven grain and are occasionally used for drawing charcoal studies of large pictures or murals. This kind of paper is usually pale yellow or dark ochre in color, suitable for charcoal drawing enhanced with white chalk. However, this really enters into the province of colored papers, which will be discussed on the following page. Finally, I should add that high-quality drawing papers can be recognized by the watermark of the manufacturer's name or logo, which is stamped or printed on one corner of the sheet.

42

43

44

45

46

47

48

Figs. 46 to 48. High-quality drawing papers carry the manufacturer's watermark, which can be seen by holding the paper up to the light.

# Colored drawing papers

About 1390 in Italy, a certain Cennino Cennini became famous as the author of a book entitled *Il Livro dell'Arte,* which enables us —almost six hundred years later— to know which materials and techniques were used by artists such as Giotto, Cimabue, Bellini, and Botticelli.

Cennini described the use of soft bread as an eraser and devoted several paragraphs to the subject of how to tint drawing paper, with reference to green, flesh pink, peach, russet, indigo, gray, and pale yellow.

All artists of the Renaissance and later periods have used colored paper for drawing, sometimes with charcoal pencil, sometimes with sanguine only, and sometimes combining these materials with colored chalks, that is, using combined techniques, but always rendering the model's luster and highlights with white chalk, as illustrated in the examples of combined techniques on pages 16 and 17.

Colored drawing paper is manufactured in the classic Mi-Teintes medium-grain by Canson, in a wide range of thirty-five colors, and in the woven Ingres paper produced by Canson and other quality manufacturers, such as those listed at the bottom of the following page.

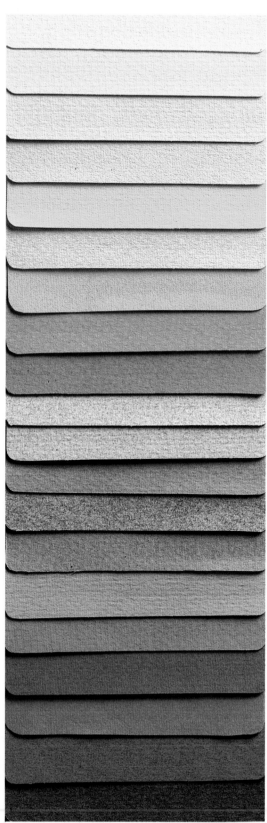

Fig. 49. A collection of colored paper samples by Canson, known as ''Mi-Teintes.'' Cream and light gray are the colors most often used for pastel drawings.

49

# Fixative liquid

Drawings in charcoal, charcoal pencil, sanguine, or pastels are not very stable and are easily smudged, blurred, or erased when touched by paper or anything else.

To avoid this hazard, the professional artist fixes drawings with a liquid consisting mainly of spirit and gum arabic or some other type of transparent resin in an approximately 5 percent solution (5 g per 100 cc of spirit). This liquid is sold ready made and is available in 300- to 400-ml spray cans (see the adjoining illustrations). The liquid fixative must be applied in various stages with the drawing in a horizontal position. Remember to wait for the first coat to evaporate and dry before applying the next one; gradually build up a fine, invisible protective film over the drawing. It is important that this process not be rushed and that the drawing lie flat on a table. This avoids raising charcoal dust and also prevents the liquid from running. Alternatively, you can hold the drawing in one hand, while spraying the fixative with the other.

Sanguine and colored chalks, in general, tend to darken a little when treated with fixative. For this reason, fixatives should not be used on colored chalks or on combined technique drawings and, in particular, should be avoided on white chalk or crayon. My advice is never to apply more than one coat to areas of white crayon, even at the risk that some parts of the drawing may be imperfectly fixed. This problem also arises with pastel drawings or paintings, since fixative liquids should not be used on pastels.

50

51

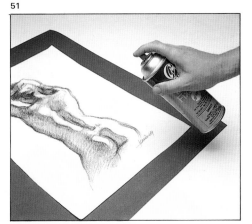

Figs. 50 to 52. Manual or aerosol spray is essential for fixing charcoal drawings. Colored chalks should be given only a very brief, sparse coating in order to avoid darkening or intensifying the colors.

52

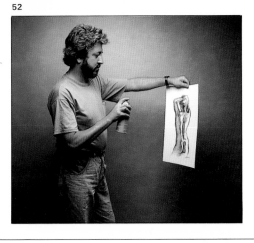

| DRAWING PAPER MANUFACTURERS | |
|---|---|
| Arches | France |
| Canson & Montgolfier | France |
| Thaler | Great Britain |
| Fabriano | Italy |
| Grumbacher | U.S.A. |
| Strathmore | U.S.A. |
| R.W.S. | U.S.A. |
| Guarro | Spain |
| Schoeller Parole | West Germany |
| Whatman | Great Britain |
| Winsor & Newton | Great Britain |

Charcoal: an ideal medium for drawing, which
is easily erased with a finger or a cloth, thus
making it possible to draw over the original,
correcting and improving as you go. Charcoal
produces a striking, deep, velvety black. Just try
it and see. Take a stick of charcoal and draw a
few lines in a zigzag fashion; experiment with
dark and light shading and filling in.
Wonderful, isn't it? Notice how easy it is to
spread the medium, "painting" a whole area
with just a few strokes. Try skimming over the
paper, and then, without stopping, apply more
and more pressure, making your strokes as
black as possible. What marvelous blacks and
grays! Now spread them with a finger and
paint! Between what you have just done and the
art of painting, there is only one small step.
Follow me and you'll see.

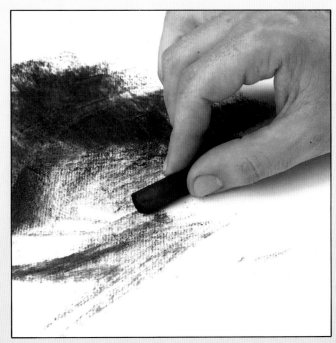

53

# TECHNIQUE
# AND PRACTICE
# IN CHARCOAL
# DRAWING

# The basic properties of charcoal

Fig. 54. If you use charcoal drawing intense strokes (A) and stumping it with the finger, you can see how the stroke is almost completely erased.

Fig. 55 (following page). If you blow hard on an area that is heavily blackened with charcoal, part of the charcoal powder will disappear (B), thus lightening and reducing the value of the area. Similarly, if you pass a clean finger over a blackened charcoal area, your finger will pick up some of the charcoal, drawing a light stripe through it (C).

*You will make more progress if you study and draw at the same time. Take a piece of charcoal, a rubber eraser, a white cloth, a drawing board, and a sheet of woven Ingres paper.*

Let's do some simple experiments to become better acquainted with the basic characteristics of charcoal.

Do you have your paper ready? Good. In a minute we'll discuss how to hold the charcoal and the position in which you should draw.

First, break the charcoal into two or three pieces, and taking one piece in your hand, draw a line and two black areas side by side. Work on these two areas to produce intense black coverage, holding the charcoal almost at the tip and in a vertical position so as to avoid breaking it. Press hard on the charcoal to create a deep, velvety black. When you are satisfied with the result, gently pass your thumb over the

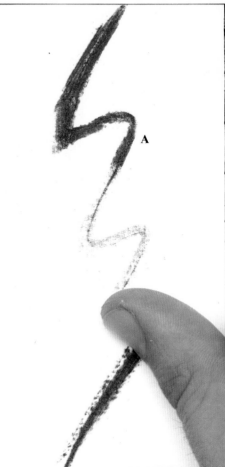

A

54

first line you drew (A), as if to brush away a speck left by the eraser. Inevitably, you will remove almost all the charcoal, leaving only a faint trace on the paper.

Now, moving very close to the paper, blow hard on the first black area you drew (B). You have blown away part of the charcoal powder, thereby reducing the intensity of the black.

Turning your attention to the second area (C), which should be perfectly black (if it isn't, apply a few more strokes of charcoal), now run the tip of either your index finger or your mid-

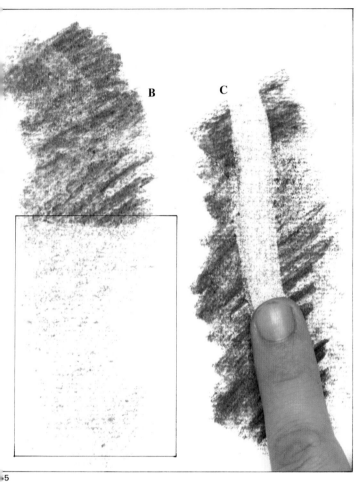

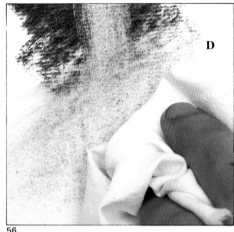

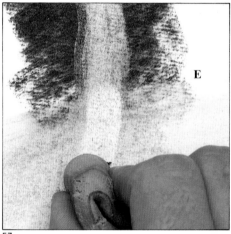

lle finger through the area from top o bottom. If your finger is clean, it vill remove a considerable amount of charcoal, creating a stripe that is less ntense than the surrounding area. Finally, take the cloth and rub it vigorously over the second charcoal area (D). You will find that the cloth has wiped away all the charcoal powder, shading or rather smudging the adjacent areas and leaving only the faintest trace of gray, which can be easily removed by rubbing the area with an eraser (E).

This leads us to the following basic conclusion: **Charcoal is unstable.**

Forgive me for belaboring such a simple point, but this unstable quality of charcoal is of vital importance if we are to understand the medium and learn how to draw with it.

The whole technique and creative potential of charcoal drawing hinges on this one fact. It even determines the way charcoal should be held, as we shall now see.

Figs. 56 and 57. With a soft absorbent cloth, such as a piece of toweling, you can wipe away part of the charcoal, leaving only a trace of the original dark area (D). Finally, the kneadable rubber eraser is undoubtedly the best means of drawing by lifting and lightening charcoal-covered areas (E).

# How to hold the charcoal

Figs. 58 and 59. To draw with charcoal, you should not hold it as you would for writing with a pencil. Charcoal is normally used for large-scale drawings, which involve working at some distance, usually at arm's length, from the drawing board. Hold the stick or piece of charcoal inside the hand as illustrated.

Figs. 60 and 61 (following page). When drawing with charcoal, you should avoid touching the paper with your hand. Occasionally, when working on specific details, it will be necessary to steady your hand by resting the tip of your little finger or your ring finger on the drawing. To darken or lighten larger areas of a drawing, it is a good idea to work with the flat side of a short piece of charcoal, since this is an easy and quick method of creating light and dark tones.

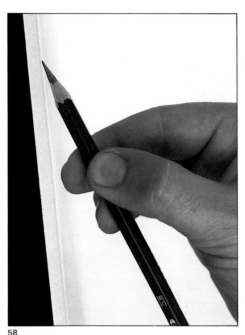

58

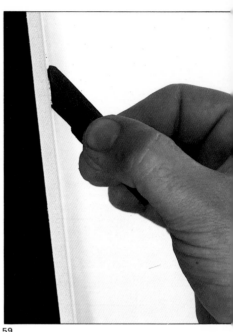

59

The charcoal should be held according to the following rules:

1. *Never hold the charcoal in the "usual way."*

Remember never to hold the charcoal the way you write, firstly, because if you do, your hand will brush against the paper and smudge or erase the charcoal; secondly, because charcoal does not lend itself to small-scale drawings.

On the contrary—and here we're entering into the possibilities of charcoal—this medium is best for large drawings, requiring the eye of a painter rather than a draftsman and a sensitivity to tone and color rather than to contour and lines.

2. *Hold the charcoal inside your hand, without resting your fingers on the drawing surface.*

Hold the charcoal almost as if you were holding a paint brush. Avoid touching the paper so as not to smudge the paint.

The best way of explaining how to hold the charcoal is by illustration and detailed description.

In Figs. 58 and 59, we see two methods of holding the material. The first shows an artist holding a charcoal lead and the second shows an artist holding a piece of charcoal. Study the position of the hand in the latter and observe the following points:

a. While the thumb, index, and middle finger hold the charcoal, the other fingers are tucked into the hand to avoid touching the paper.

b. The charcoal is held at a wider angle to the drawing surface than the charcoal lead, in other words, it is held more perpendicular to the paper.

c. The length of charcoal protruding above the fingers is shorter than what is common practice with a pencil; in other words, hold charcoal nearer the drawing tip.

d. It is better to draw with a broken-off piece of charcoal than with a whole stick.

3. *Occasionally, if you need to steady your hand, you may support it by resting your little finger on the drawing.*

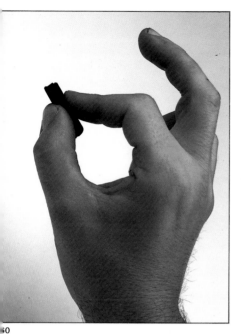

60

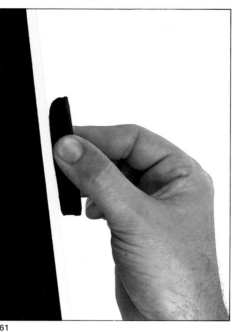

61

62

Fig. 62. To draw with charcoal, it is usually necessary to work with an easel and a drawing board. The artist may work close to the surface when drawing fine detail or at arm's length to maintain a wide overall view of the work in progress.

## Drawing with a charcoal wedge

Charcoal readily takes on a wedge shape after only a few strokes. You will soon see for yourself how, by varying the angle of the charcoal against the paper, you can create larger or smaller broad tonal areas. You can produce fine lines by using the tip or corner of the wedge, just as you can with the charcoal lead pencil.

## Drawing with the flat side of the charcoal

Figure 61 illustrates another way of holding the charcoal—in a horizontal position, or parallel to the drawing surface—to produce marvelous, broad strokes like those shown on the following page. This is an excellent way of creating large areas of light and dark values, and of filling in backgrounds, fabric, expanses of sky, and so on.

## The position of the artist when drawing in charcoal

The arm should be extended and the drawing board almost vertical when working in charcoal. The vertical position allows excess charcoal powder to fall to the floor, rather than remaining loose on the surface of the drawing.

Now all that remains is for you to practice with the medium; experiment with holding the charcoal and drawing with it.

# A study of the medium

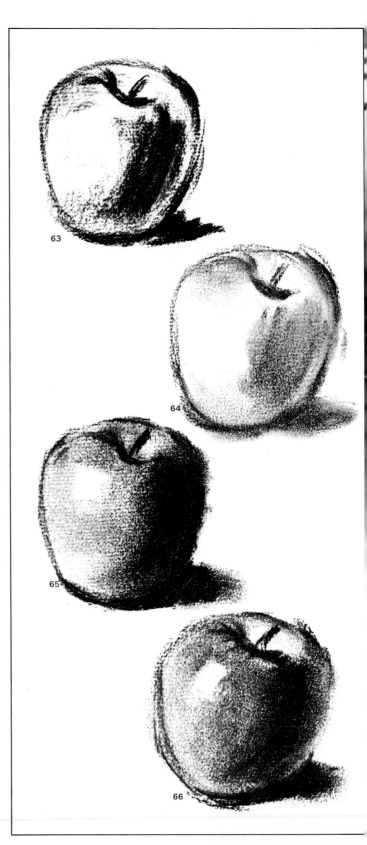

63

64

65

66

Before embarking on charcoal drawing as such, using only a sheet of paper, a piece of charcoal, and your fingertips for blending, let's first study the technique as applied to drawing an apple.

Let's suppose that the model is an apple with the light coming from one side (see Figs. 63 to 66).

Using a wedge of charcoal, we draw a series of dark lines to represent the darkest areas of the apple (Fig. 63). Now go over these lines with your finger. You can see that almost all the charcoal has disappeared and that the drawing has lost intensity (Fig 64).

But this is just as we expected. Now rework the area with the charcoal stick and blend it again. Then repeat the whole process (Fig. 65). How is it coming along?

By now, the drawing will have changed significantly; and your blackened finger has become almost like another stick of charcoal, so that you can actually "paint" with it!

Now, we must check that, while building value on the apple by recreating the sheen and the brighter areas of the model, we didn't forget to pick out the highlights.

But if we did, how can we put it right? Should we rub out with an eraser? No, it's much simpler than that! Just pass a clean finger over that part of the drawing, as if you were painting, and you will remove part of the charcoal, creating more light in that area. Now you can put the finishing touches on the shadows, this time using the charcoal without blending (Fig. 66).

Remember the three important points you have learned in this short lesson; they are always applicable to all kinds of charcoal drawings.

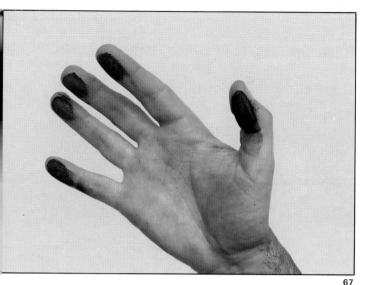

**67**

**68**

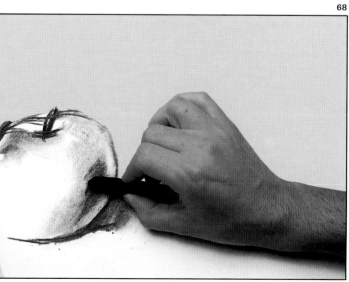

**69**

1. *For blending, your fingers must be saturated with charcoal powder* (Fig. 67).

Once your fingers are completely saturated with charcoal, the gray and black areas you have "painted" with them will be more stable. They cannot be erased and smudged as easily as strokes drawn directly with a charcoal stick. Why? Because the perspiration on your fingers contains a small amount of natural oil that combines with the charcoal and fixes it.

2. *Use a clean fingertip to lighten a tone* (Fig. 68).

The fingertips, the back of the hand, or indeed any part of the hand may be used. You can use this trick for any area of shadow, gray tone, or gradation to lighten a tone. Just brush your finger back and forth, up and down, or simply tap the charcoal more or less gently, depending on the degree of lightness required.

This process of creating light and dark effects, alternately using clean and charcoal-covered fingers and yet another clean finger for adding or reducing value, followed by direct application of the charcoal stick and blending once again, is largely a matter of instinct. Quick, confident drawing is characteristic of the true artist.

3. *Apply the charcoal directly, without blending, to reinforce the drawing* (Fig. 69).

This technique gives the dense finish that we associate with charcoal. I must add at this point that one should not expect charcoal drawings to have a totally uniform, perfect harmony of grays and gradations. Don't be afraid to reinforce an area you have already blended; apply the charcoal directly to the darkest areas and leave it unblended.

# Modeling with a single stroke

Figs. 70 to 73. With just one thick, bold stroke inside a circle, it is possible to represent the volume of a sphere and create all the needed effects of light and shade.

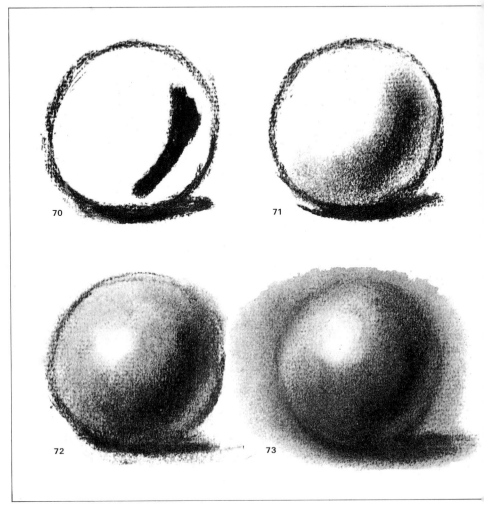

First, let me stress some general aspects and applied methods, such as those involved in modeling a sphere from a single charcoal line.

Imagine a sphere drawn with a *lead pencil*. Remember that when drawing with a lead pencil, you must create values of light and shade by filling in and then patiently reducing the tones to make areas of semi-shadow, dark areas, and the softer, lighter tones of reflections. Contrast this method with the ease and simplicity of performing the same task in charcoal. Now join me in the following exercise.

First, we draw the outline of the sphere and a bold black line representing the area in shadow (Fig. 70). Now, with the tip of the middle finger caked in charcoal—this is most important, because if there is no charcoal on your finger, the technique will not work properly—we blend and spread the original bold line (Fig. 71).

Now, we draw over the same area again, and once again use our fingers to blend the charcoal. We repeat the process as often as necessary to complete the modeling of the sphere. We can even shade in the lighter areas with the charcoal still on our fingers, leaving the uncovered white of the paper to represent the brightest area of direct light (Fig. 72). Finally, using our fingers, we break down the outline of the sphere by *blending it outward*, defining the shape of the sphere with tone rather than line (Fig. 73).

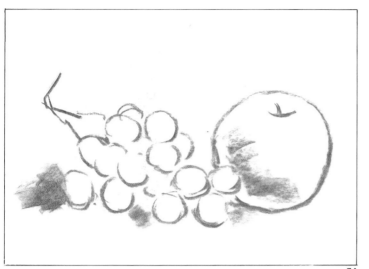

74

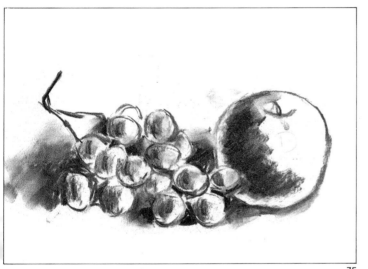

75

Now apply this same technique to drawing an apple and a bunch of grapes (Figs. 74 to 76). Remember the following points:

1. *A charcoal line is totally blended by using a finger caked in charcoal.*

In order to position and build up shadow, as in the grapes, for example, all we have to do is draw a charcoal line corresponding to the darkest area of shade and then spread it by blending and modeling with the fingertips. Obviously, if the shadow to be drawn is dark, we'll have to use very bold, thick strokes of charcoal. If, on the contrary, the shadow is light, we'll draw a softer, fainter line and blend it carefully. All this is more complicated than it seems at first sight, but by now you know the rules: First, intensify with the charcoal; then, lighten with a clean finger, adjusting and readjusting the drawing until the tone is exactly right.

2. *To create a sharp gradation, draw a dense black line in the darkest part and shade by blending with a finger covered in charcoal.*

You can see this technique illustrated in the darkened area of the shadow on the apple in Fig. 76. First, I simply intensified that part of the apple using the full black of the charcoal, and then, with charcoal on my finger, I spread and shaded into the lighter area as necessary.

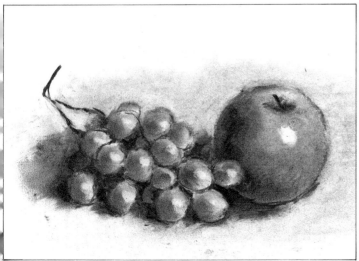

76

Figs. 74 to 76 (next page). Here you can apply the lesson on drawing a sphere to drawing an apple and a bunch of grapes.

# Drawing a still life in charcoal

Figs 77 and 78. Here I am in the first stages of this practical exercise in charcoal. Why don't you try it too? All you need is an easel, a board, a couple of clips for fastening the Ingres paper to the board, and a model such as this one—a pottery jug, a bunch of grapes, and a apple.

Welcome to my studio. It's an attic room, measuring $13 \times 29$ ft ($4 \times 9$ m). As you can see in the inset photograph, I have made a simple still life composition consisting of a jug, an apple, and a bunch of grapes (Fig. 78).
I'm going to draw this subject in charcoal on a sheet of white Ingres paper, measuring $14 \times 20$ in ($35 \times 50$ cm). Then I'll record, step by step in a series of photographs, the progress of this exercise in charcoal drawing from a model.

Select a model similar to mine, take a sheet of Ingres paper with the dimensions I have given, and we're ready to begin.

77

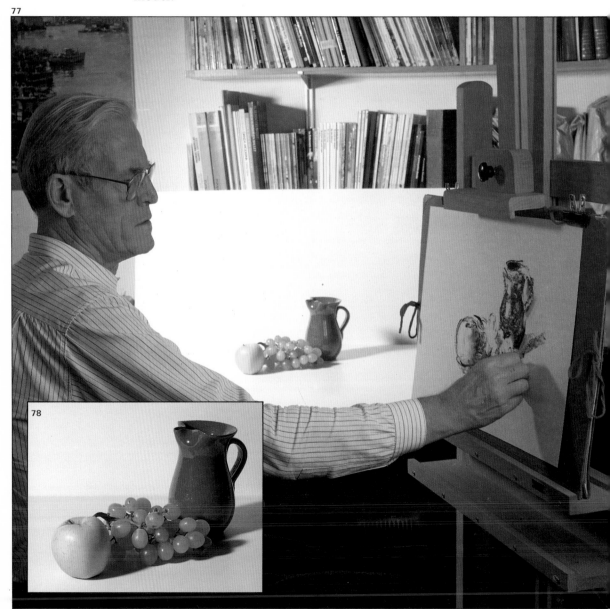

78

# First stage: boxing up

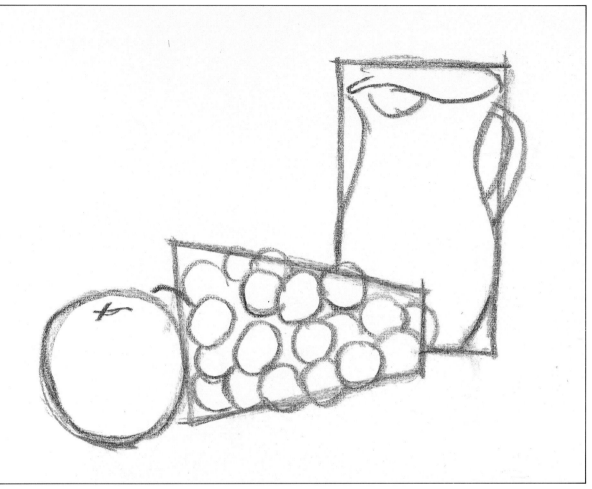

79

It is almost as if charcoal were intended for boxing up, drawing studies of form, light, and shadow, and sketching compositions. The fundamentals of boxing—speed, mental assessment, and an overall view—are perfectly suited to the medium of charcoal, since in just a few minutes, it is possible to begin to model and create shade effects, to rub out and start again, to wipe out with a cloth and remodel!

Now let's see this in practice:

Use lines to box up the model. You can see how I have dealt with the boxing-up stage in Fig. 79. Given the simplicity of the model's shapes, begin by drawing tight boxes. Work quickly, but carefully, keeping in mind the model's dimensions and proportions, especially those of the grapes, which must be modeled carefully, one by one. Now box the shadows, drawing in medium and dark values with charcoal, and at the same time using your fingers to blend them.

Fig. 79. Now, if you are ready to begin, you can box up the jug by drawing a simple rectangle, the apple by drawing a circle, and the bunch of grapes in a less regular but equally simple shape. To help you understand and carry out this exercise, I have made a line drawing of the elements that constitute this still life.

# Second stage: light and shadow

Bearing in mind what you have just learned, draw the shadows of the model—apple, grapes, and jug—with thick strokes of charcoal, which you can then blend with your fingers. Don't forget that you can use the flat edge of the charcoal (for rapid shading of the background, for example), and remember to use your fingers as if they were paint brushes to blend, intensify, lighten, and shade.

Then study and practice building values, contrast, and atmosphere, until you reach the stage illustrated in Fig. 80.

Finally, remember that at this stage you should not use an eraser, but leave the original white areas and reflections untouched.

Fig. 80. Here is the second stage of the drawing: a sketch with the effects of light and shade drawn in charcoal and blended with the fingers.

Figs. 81 and 82. Treating this sketch as a dress rehearsal, check to make sure the structure of the drawing is right. Now it is customary to erase it by gently dabbing with a cloth or simply wiping the cloth over it (Fig. 82).

Fig. 83. Occasionally, after wiping out the first stage of the drawing, you may find greasy marks left on the paper by your fingers. It is very important to avoid making such marks.

80

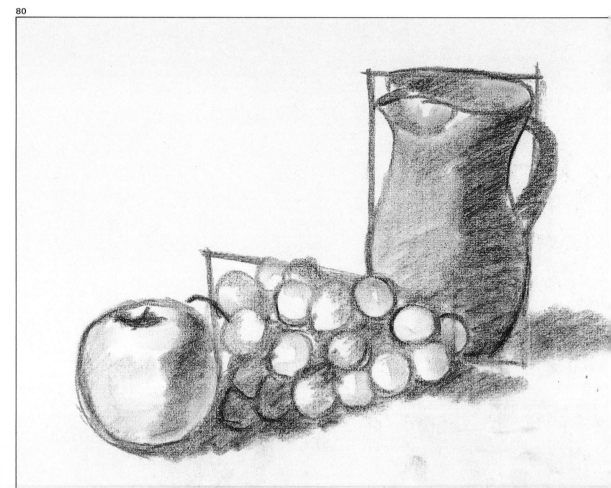

# Erasing the drawing

What I am about to describe may seem rather like a bad joke. Taking a cloth, you wipe it over the entire drawing to erase it, as if all your work had been for nothing.

It may seem absurd, but that's how we work, and I advise you to do the same. Don't worry—its all part of the game. You would see just this process of repeatedly doing and undoing, erasing and redrawing, in any life drawing class at any art or fine arts school.

We wipe out with the cloth in either one of two ways: by gently dabbing or by rubbing in a circular fashion. With the first method, very faint but perfectly visible traces remain of the black and gray areas.

The second method results in a more blurred and grayer drawing, as if we had applied a layer of light gray shading to the whole surface of the paper. However, the original lines of the drawing will show through the uniform gray tone.

My advice is that you should use both methods, first, dabbing and then, wiping, cleaning, and erasing as much as possible.

Once you have finished, check one important detail: Look for any finger marks you may have made by touching the paper before or during the drawing. The perspiration on your fingers contains a minute quantity of natural oils that can leave a glaring stain on the paper. Remember: *Perspiration will leave a mark.*

Remember, too, that if such a mark appears on a large, light gray area of charcoal drawing, *it is extremely difficult to disguise.*

We are ready for the end of the rubbing-out stage. (For the conclusion of this stage, see the following page.)

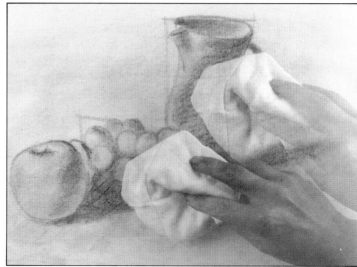

81

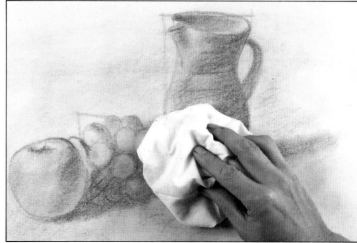

82

83

# Third stage: starting again

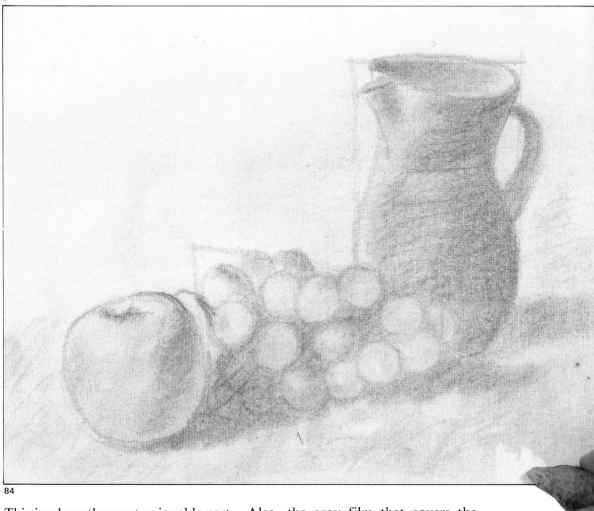

84

This is where the most enjoyable part of a charcoal drawing begins. Because the artist experiences a kind of mental relaxation that allows him to take a better, fresh look at his subject, it's as if the original sketch, when contrasted with his model, were pointing out his mistakes: This part should be narrower; that shading was too dark, and so on.

Also, the gray film that covers the paper after the drawing has been erased makes it much easier to build value, facilitating work with the charcoal, the fingers, and the rubber eraser. Experiment for yourself, in a corner of the drawing, by picking out a small white area with an eraser.
Easy, isn't it?

Fig. 84. The drawing ha been rubbed out with cloth, leaving behind visible trace of the origi nal, which can now b revised and corrected This stage makes valu building, blending, an work with the rubbe eraser much easier.

# Fourth stage: creating value with a kneadable eraser

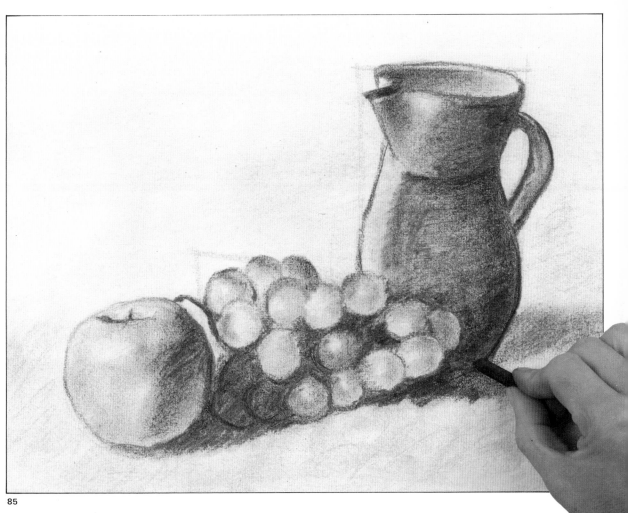

85

Now begin building up the drawing once again, this time using more definitive, secure strokes, calculating the precise angle and position of every shape and line. Work carefully and without interruption, creating shade and value. Work *progressively, step by step,* and take your time.

Then, when the composition is beginning to take shape—a soft, delicate shape, in which there is still no suggestion of any strong, intense, forceful black—open up the white areas, those shiny reflections on the apple, the tiny bright reflections on every single grape, and the gleaming reflections on the jug! What enormous satisfaction you feel as you do this!

Let's see the result on the next page.

Fig. 85. Now it's time to build up value progressively, calculating and comparing shades and nuances until you reach an advanced stage in the drawing when all that remains is to pick out the highlights and strengthen the contrasts.

# Fifth stage: rubbing out and drawing

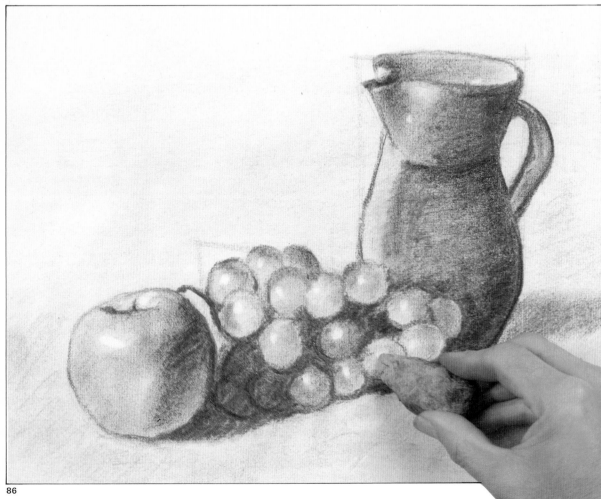

86

Fig. 86. Now comes the *fun* of drawing with a rubber eraser, "opening up white areas and picking out highlights" on the grapes, the apple, and the jug. For this job I recommend using a kneadable rubber eraser, which can be molded into whatever shape will perform the task most efficiently.

As you know, charcoal can be removed by using a cloth, a rubber eraser, or fingers. Your choice of method will depend on the size of the area to be corrected and its position in the drawing. If it is a large, self-contained area, you can use a cloth, for example, to rub out a hand or arm of a figure drawn against a plain background. To rub out a small area, where using a cloth might smudge the surrounding drawing, it is better to work with an eraser or with clean fingers.

Now we are going to draw by the rubbing-out method, using a special kneadable rubber eraser, according to the following technique. (As you study this lesson, please refer to the pictures and have a kneadable rubber eraser at the ready.)

At first glance, the kneadable rubber eraser doesn't look very different from any other ordinary blue or light gray eraser (Fig. 87). But if you twist and press it between your fingers, you will immediately see that it is a soft, pliable eraser, with a texture similar to plasticine (Fig. 88). This material can be molded into various shapes.

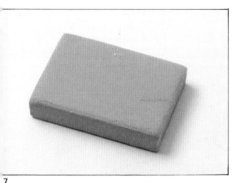

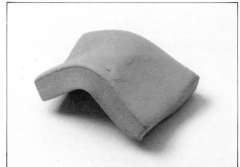

Figs. 87 to 92. The kneadable rubber eraser looks like any other eraser (Fig. 87). However, it is easily twisted and molded with the fingers (Fig. 88). It can be pressed and pinched into a variety of shapes, such as a pointed cone, for example, which can be used for picking out highlights on the grapes (Fig. 90). Of course, in this case, or when you rub out a large, darkly shaded area, the eraser becomes loaded with charcoal powder and ceases to erase effectively (Fig. 91). The solution is to renew the eraser by stretching and kneading it (Fig. 92).

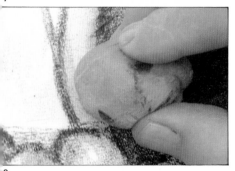

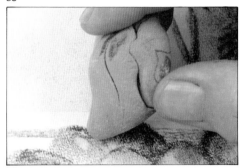

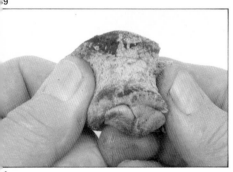

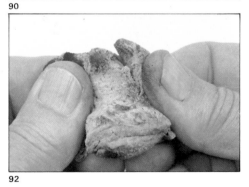

Thanks to the pliability of this materi-al, you can use it to *draw* a dot, a line, or an outline by rubbing out the char-coal (Figs. 89 and 90). You will see that the kneadable eraser can draw and rub out like any other eraser, but it also be-comes impregnated with charcoal (Fig. 91). This brings us to a special tech-nique for "renewing" the kneadable eraser: A clean drawing tip or edge

must be made by folding the rubber so as to enclose the charcoal, stained area. Then it is ready to use again. When a large area of charcoal is rubbed out and the eraser becomes very dirty, we must renew it by stretching the eraser and bending it back on itself until the clean, natural color of the eraser emerges. Then the eraser is ready to be used again for drawing (Fig. 92).

# Sixth and last stage: enhancing the volume

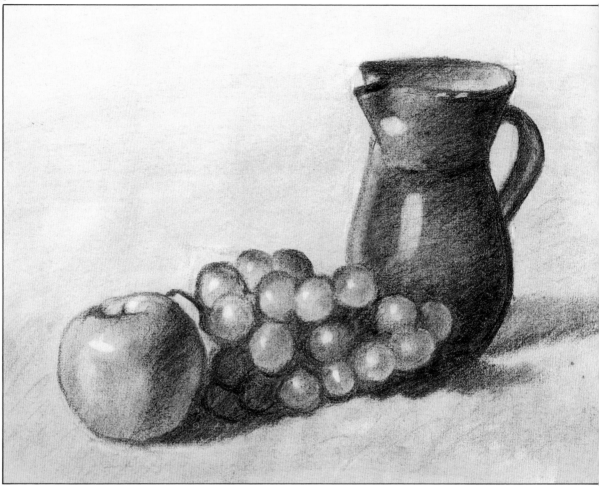

93

Have you tried and understood the technique of using a kneadable rubber eraser? Have you practiced using it to open up and draw highlights and reflections, to lighten shapes or areas by dabbing them with the material rolled into a tiny ball? Good. Now we come to the last stage of this exercise in charcoal drawing.

Give the finishing touches to your drawing, as I have done, enriching the blacks, creating extra volume and con-

trast, and enhancing value and color by reducing the darkest areas.

When you think you have finished, wait a while before fixing the drawing. Leave it until tomorrow, or the next day, and then take a fresh look at it. This will enable you to see more clearly what you can do—or what you shouldn't do—to improve the drawing.

Fig. 93. This is the final result of contrasting light and shade, of opening up the bright areas and reflections, and harmonizing the background.

# Sketches and studies of the human figure in charcoal

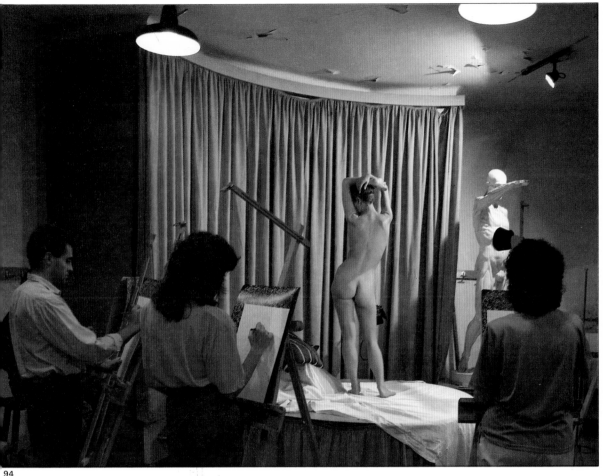

94

Referring to color and to the artist's perception of color, even when he is drawing, Henri Matisse said: "A good sense of color is evident even from a charcoal sketch."
Exactly.
On the previous pages, we have seen how charcoal can suggest color, encouraging us to paint.
That is why all students of fine arts learn to paint by doing charcoal drawings, especially nude figure studies. This is a perfect subject for a charcoal drawing.
It is an indispensible part of the artist's training, since there is no subject of such beauty, of such artistic and didac-tic value as the naked human figure. In every city, there are private or public art schools, societies, or academies that offer classes or organize sessions of live, nude figure drawing. There are also professional models, both men and women, who pose at artists' studios for two or three hours at a time. It is possible, in this way, to work with two or three other artists in order to cut down on expenses. Join one of these groups; it isn't difficult, and it is essential.

Fig. 94. Charcoal is a particularly suitable medium for sketching and drawing studies of any subject, whether it is a landscape, a still life, or a portrait. But charcoal is especially useful and effective for studies of the human figure and, particularly, for sketching and drawing nudes. It is the method used in all fine arts schools.

# Examples of charcoal figure drawing

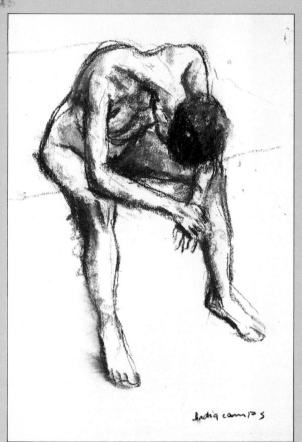

95

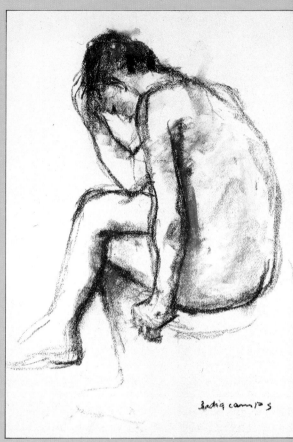

96

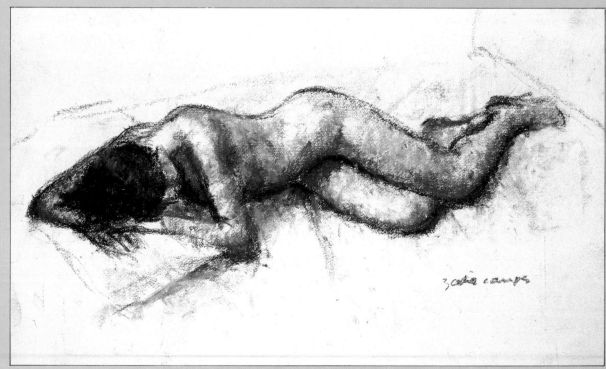

97

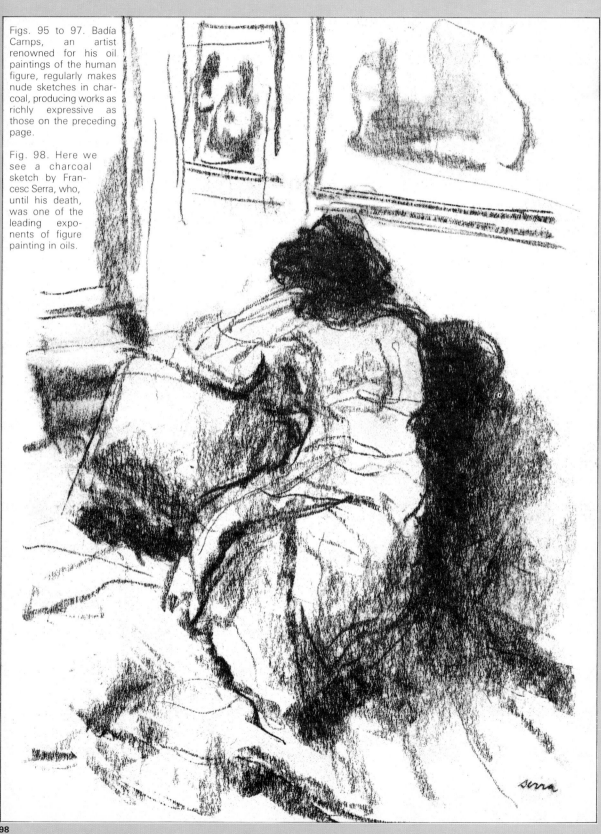

Figs. 95 to 97. Badía Camps, an artist renowned for his oil paintings of the human figure, regularly makes nude sketches in charcoal, producing works as richly expressive as those on the preceding page.

Fig. 98. Here we see a charcoal sketch by Francesc Serra, who, until his death, was one of the leading exponents of figure painting in oils.

The next step will be studying, drawing, and practicing with charcoal pencils, sticks of natural or artificially compressed charcoal, bars of charcoal and clay, and hard and soft Conté pencils, bars, and sticks. This exercise is similar to the previous one using charcoal, but offers a wider range of possibilities and gives greater definition because forms of charcoal are blacker, more stable and flexible, which make it a better medium for creating tonal values and contrasts. They are *the ultimate* in drawing materials.

We will study this medium closely in the following pages, discussing its properties and its basic techniques. Then we will apply it to a complete practical exercise.

99

# TECHNIQUE AND PRACTICE USING THE CHARCOAL PENCIL AND ITS DERIVATIVES

# General Characteristics

We will now study the properties, the basic techniques, and the possibilities of the charcoal pencil and its derivatives: artificially compressed charcoal bars, black chalk, and charcoal and clay leads. First, we'll consider the basic features of these materials, of which compressed charcoal pencil is a prime example:

1. *It is more stable than charcoal.*
2. *It gives a more intense black.*
3. *It is the most versatile medium for creating value and variety of tone (Fig. 100).*

*It is stable:* It has a stability half way between charcoal and lead pencil. It adheres to the paper less than graphite, which is sometimes very difficult to blend, but it is not as unstable as charcoal, which, as we saw in the preceding chapter, is easily blown away or wiped off with a cloth or fingers.

*It is black:* It produces an intense, matte, velvety black, without any sheen or luster. Blacker than charcoal lead pencils and charcoal itself, it is possible to achieve absolute contrasts using this medium.

*It is versatile:* Not only is it easy to use, it flows smoothly and offers a maximum range of tonal gradations and values, making it possible to achieve great subtlety of line, color, and shading.

In addition, this medium is available in a wide range of qualities and gradations, from black chalk or artificially compressed charcoal sticks, leads, or charcoal to clay bars with a hardness similar to graphite, but producing an intense black like charcoal.

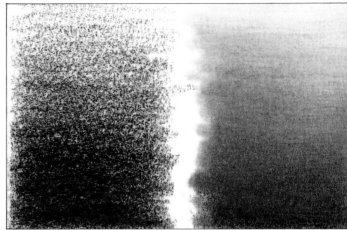

100

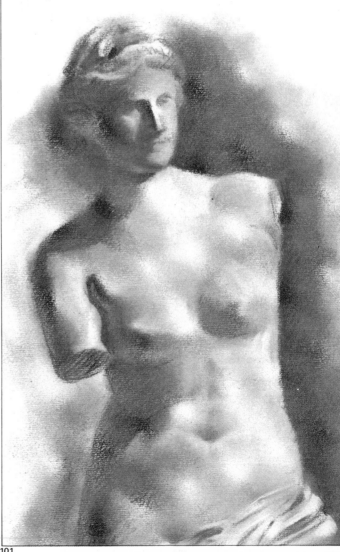

Fig. 100. Here are some examples of the intense black and the wide range of grays possible with a charcoal pencil.

Fig. 101. The charcoal pencil is the ideal medium for drawing an academic study from a plaster cast of a classical sculpture, such as this Venus di Milo.

101

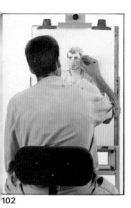
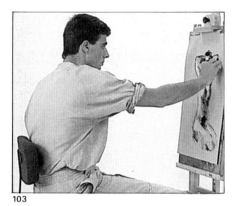

Let us now study the method used to work with compressed charcoal pencils and their derivatives.

They are used for medium- or large-scale, full-sheet drawings; place the drawing board in a vertical position and use an easel (Figs. 102 and 103). You may hold the charcoal pencil, bar, or stick in the normal fashion for writing or inside the hand, whichever you prefer.

102  103

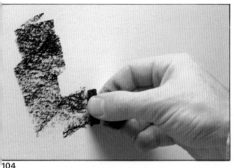

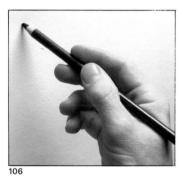

104  105  106

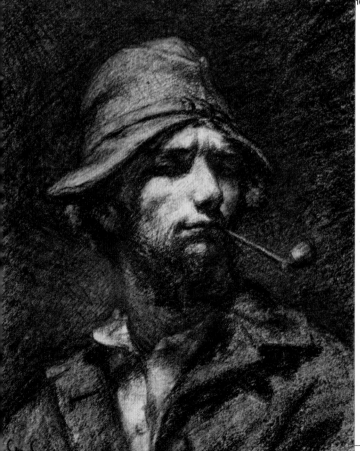

107 When drawing with chalk or artificially compressed charcoal, you can use a small piece of a stick or bar to draw broad, flat strokes, as if you were using a piece of charcoal or colored chalk (Fig. 104).

We have already seen how the charcoal pencil and its derivatives may be used for any subject, from the classic study of a plaster cast or reproduction of an ancient Greek sculpture, such as Venus di Milo on the preceding page, to a free-hand drawing such as this powerful self-portrait by Courbet. Drawn unblended, the shading and tonal values are created only with bold lines.

Fig. 107. Gustave Courbet (1819-1877), *Man with a Pipe* (self-portrait), charcoal, Wadsworth Atheneum, Hartford, Connecticut. This charcoal drawing is unblended.

# Basic techniques

Fig. 108. In the illustrations you can see three examples of the basic techniques when you draw with charcoal pencil: *Academic technique,* with grays and stumped grades; *unblended technique,* with non-stumped strokes; and *combined technique,* with unblended strokes on top of stumped areas.

The charcoal pencil, like compressed charcoal sticks, black chalk, sanguine, and colored chalks, can be used in three ways, employing three basic techniques as illustrated in Fig. 108:

A. *Academic technique,* consisting of perfectly blended shading and tonal values.

B. *Unblended technique,* in which the shading and tonal values are created using unblended lines.

C. *Combined technique,* in which blended shading is reinforced with unblended lines.

Figures 101 and 107 on preceding pages show examples of the academic technique and unblended technique.

In Figs. 101 and 107 we see how it is possible to achieve tonal gradation using charcoal and a stump, bearing in mind that the intensity of charcoal and its derivatives can produce excessive blackening. Indeed, in Fig. 109 you can see how tonal gradation created with a charcoal pencil (A) and blended with a stump (B) can become excessively dark and spoil the original shading and harmony.

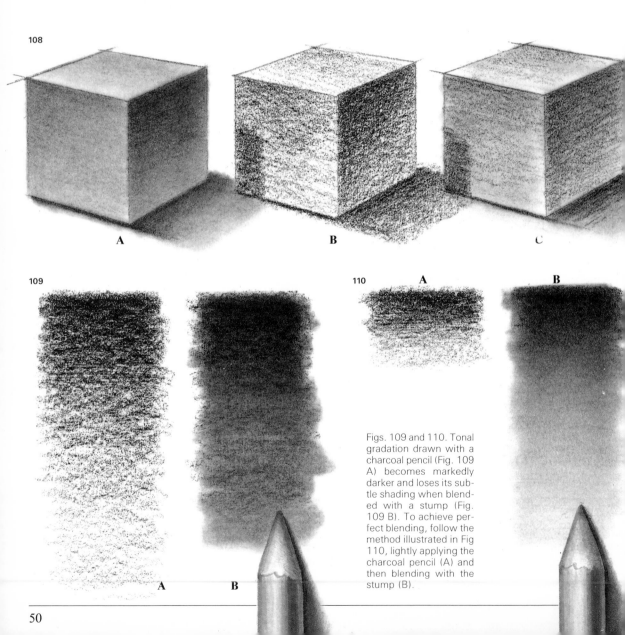

108

A          B          C

109          110    A          B

Figs. 109 and 110. Tonal gradation drawn with a charcoal pencil (Fig. 109 A) becomes markedly darker and loses its subtle shading when blended with a stump (Fig. 109 B). To achieve perfect blending, follow the method illustrated in Fig 110, lightly applying the charcoal pencil (A) and then blending with the stump (B).

A    B

111

112

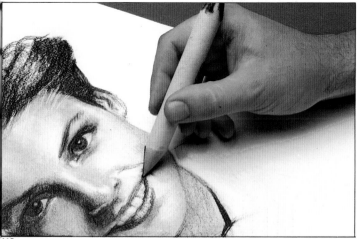

113

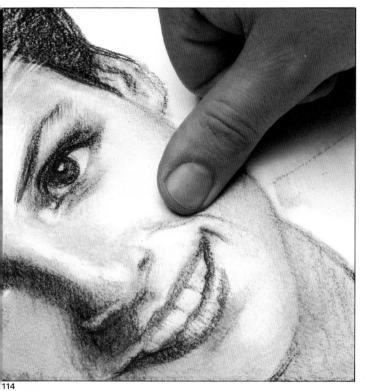

114

For perfectly blended tonal gradation, proceed as in Fig. 110, in which we see a small area of shading in charcoal pencil (A), which, when blended with a stump, produces gradual shading similar to the original one in Fig. 109 A.

Charcoal pencil and its derivatives may be blended using either your fingers or stumps, although practice will soon demonstrate that it is easier and cleaner to work with stumps. Work with two or three stumps, using them as you would brush, keeping some for light tones and others for dark tones.

Sometimes, however, you will find it necessary to clean one of the stumps you are using by wiping it on a piece of paper, which you should have ready for this purpose (Fig. 111). You might find it convenient to "paint" an area of intense black on a piece of paper, from which you can load the stump with charcoal (Fig. 112). You can use the stump directly to draw more or less diffused lines, both faint and dark; you can also use it to transfer charcoal from one part of a drawing to another. Finally, remember that your fingers can be used for shading, blending very light grays, or darkening either very large of very small areas of a drawing.

Figs. 111 and 112. To empty and clean the stump, simply rub it against a piece of drawing paper (Fig. 111). You can "load" a stump with charcoal by picking up charcoal powder from an intensely black area (Fig. 112).

Figs. 113 and 114. When drawing with charcoal pencils, you can blend with either a stump or your fingers. You can use a stump loaded with charcoal as if it were a pencil to draw strokes, lines, shadows, and so on.

# Charcoal sketching

Here are the progressive stages of a sketch done in ten minutes, using a statue of Venus di Milo as a model. The sketch was drawn using a soft compressed charcoal pencil on medium-grain Canson paper.

In Fig. 115, we can see the preliminary study for the sketch, starting with a vertical line drawn full length from top to bottom and three diagonal lines used to position the shoulders, the breasts, and the pelvis. With these initial calculations of the basic dimensions, you can use the charcoal pencil to quickly elaborate the outline or "framework" of the model, as Ingres called it.

Now we go over this outline, clearly defining the contours of the subject. We also shade in areas of light and shadow, remembering not to use the stump at either this (Fig. 116) or the final stage of the drawing.

The drawing should be well-defined by the time you reach the final stage, and it should not be necessary to correct or calculate the dimensions and proportions of the subject any further. The artist should use all the remaining time to create value, that is, build up shading with a limited range of tones to achieve contrast and volume (Fig. 117). Finally, we should stress that this type of exercise—sketching in a limited amount of time, for example, three, five, or ten minutes— is excellent training because it gives the artist practice and helps develop confidence in the art of drawing.

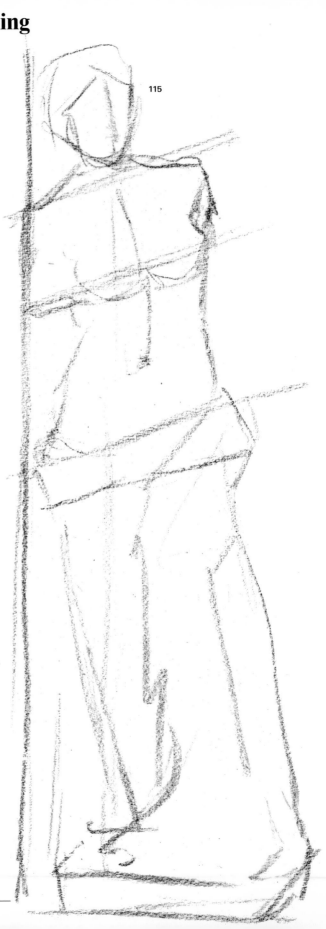

115

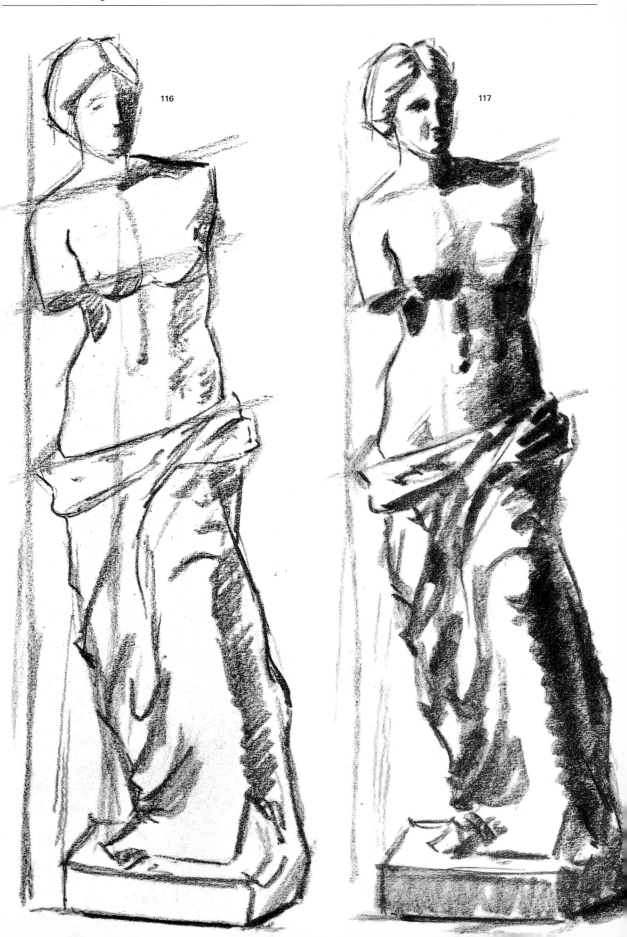

# Sketch and artistic drawing in charcoal

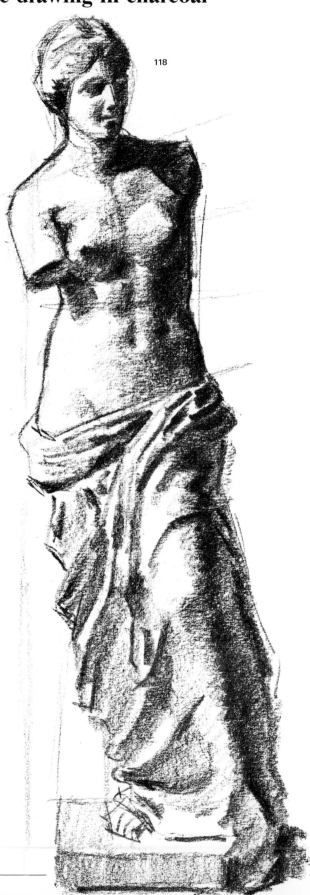

118

On the right, we have another sketch of Venus di Milo that we drew in fifteen minutes. Here again we used charcoal pencil on medium-grain Canson paper and sketched without any blending, achieving a spontaneity and energy characteristic of unblended line drawings (Fig. 118).

Now, look at a drawing of the head of Michelangelo's Moses (Fig. 119). Also worked with a charcoal pencil, this drawing was taken up to its final stage using stumps, fingertip blending, and blending with an eraser, making the very most of the medium's potential, including the use of charcoal and Conté pencils. In this illustration we can observe and admire the extraordinary effect produced by the medium we are studying and its almost limitless versatility in calculating and creating values, using a vast range from light, medium, and dark grays to pitchblack.

Fig. 118. An unblended, charcoal pencil sketch of the sculpture Venus di Milo.

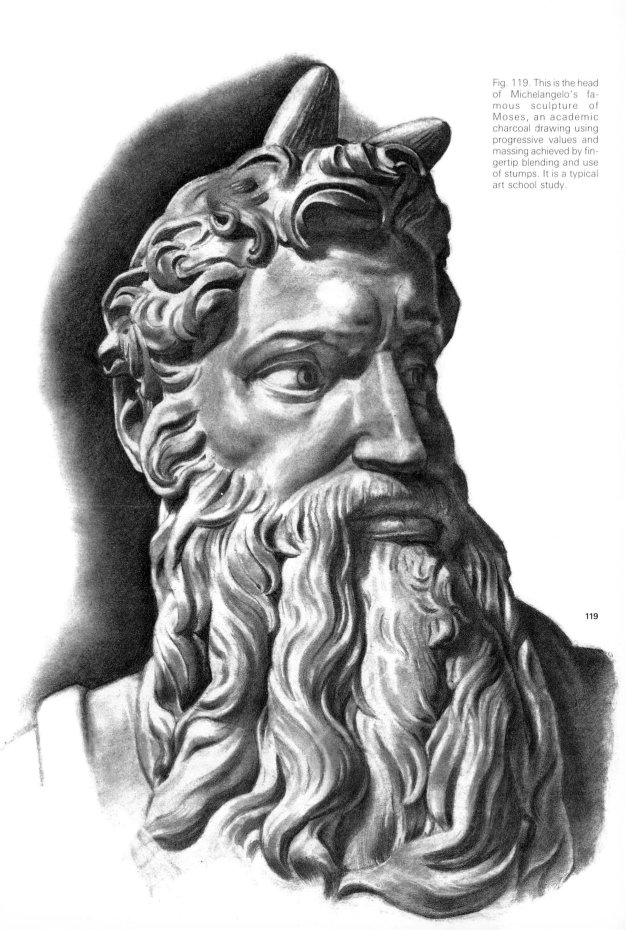

Fig. 119. This is the head of Michelangelo's famous sculpture of Moses, an academic charcoal drawing using progressive values and massing achieved by fingertip blending and use of stumps. It is a typical art school study.

119

# A charcoal pencil drawing of the face of Beethoven

At the end of this book, you will find two prints: a frontal photograph of the half mask of the immortal musician Ludwig van Beethoven reproduced in plaster, and the photograph of a still life composition consisting of various pottery objects.

Remove these prints from the book when you are ready to use them as models for charcoal and colored chalk drawings.

First, let's take Beethoven's half mask. Look at the model in Fig. 120 and also the photograph you are going to use as a model (page 109). In this exercise you will copy the photograph using a compressed charcoal pencil, following step by step the process I'll use to draw the plaster half mask of Beethoven from the original model.

Note in Fig. 122 how you should place the print from which you are working against a file folder as a support, illuminated by a table lamp or spotlight. Take note of the position of the above mentioned electric light in relation to the print and yourself (Fig. 123). It should cast light over both the model and the drawing paper. Also check the position and the distance between you and the model. Leave some distance between the paper and you by working at arm's length and keeping a clear view of both the model and your drawing without continually having to raise and lower your head.

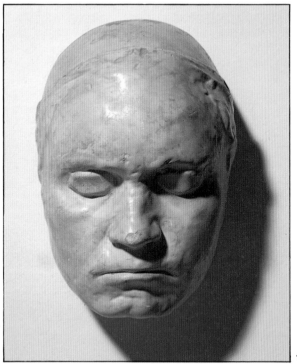

120

121

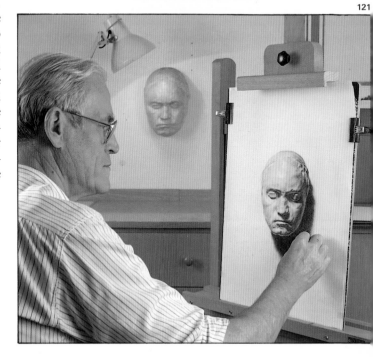

Fig. 120. This is the model: a reproduction of the authentic half mask of Beethoven attained specially for this book from the Beethoven Museum in Bonn, West Germany.

Fig. 121. Here I am putting the finishing touches on Beethoven's face. In the background, you can see the model illuminated by a desk lamp. On page 109, you'll find a large-scale reproduction of this mask.

# Materials and lighting

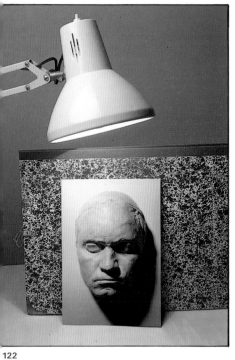

122

123

All set? Let me see... the drawing board should be resting on your lap against the edge of the table, the woven Ingres paper secured with drawing tacks, the charcoal—you will do the preliminary boxing up in charcoal—a rag, and the eraser should all be ready.

124

Figs. 122 and 123. I hope you will complete this charcoal drawing exercise using as your model the print of Beethoven's half mask reproduced on page 109. Here we have the model on a table leaning against a folder file, (you could use some books for support) in an almost vertical position (Fig. 122). You are sitting opposite the model with the drawing paper secured to a board or a file which you lean against the table. Both the drawing paper and the model are illuminated by the table lamp (Fig. 123).

Fig. 124. On the left, we can see all the materials required for this exercise: the model, woven Ingres drawing paper, tacks for securing paper to the drawing board, charcoal sticks, charcoal pencils, a kneadable rubber eraser, a soft, absorbent rag, and an adjustable table lamp.

# Stage one: preliminary boxing up

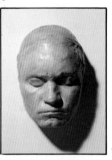

Fig. 125. A photograph of the model.

Fig. 126. First, draw an oval inside a rectangle, locating the center of the face and situating the eyes by dividing the oval with a cross.

125

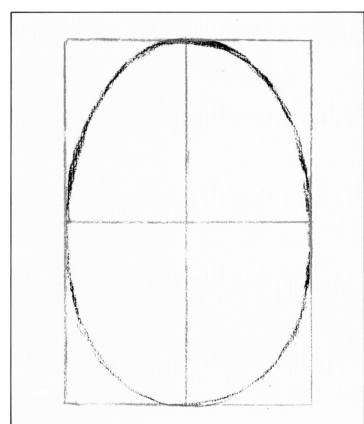

126

I take it for granted that you know about the canon of the human head and that it refers to dimensions of the ideal head: that is, a head of ideally perfect dimensions. (The canon of the human head is explained in great detail in *How to Draw Heads and Portraits,* another volume in this series.) Of course, every human being's head differs slightly from the ideal. This is the case with the head of Beethoven, which, if we were to apply the ideal canon, would be less than perfect in some respects (Figs. 129 and 130). Nevertheless, the canon is still a very useful and efficient means of calculating the proportions and structure of

127

the individual face or head.
I recommend that you use the canon's geometrical grid, as this will give you an excellent box for structuring Beethoven's face and representing it in a quick and easy way. Bear in mind the ideal proportions of the human face and practice as you go.

Figs. 127 and 128. Geometric grid showing the canon of the human head. The distance between the eyes is equal to the width of an eye, and the height of the ears corresponds to the distance between the eyes and the base of the nose.

128

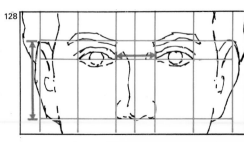

# The canon applied to the drawing of Beethoven's mask

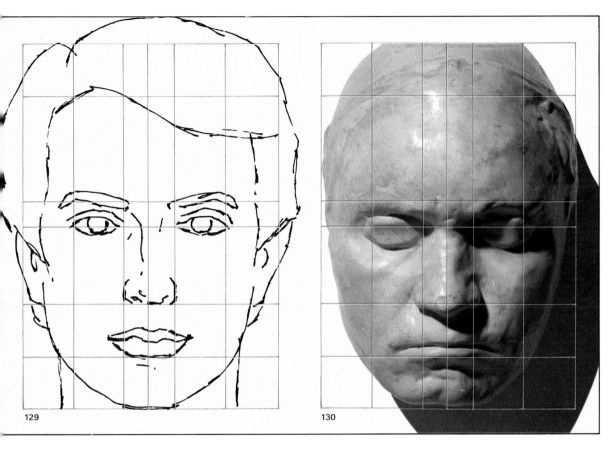

129        130

Draw the face of Beethoven, about 10 in. (25 cm) long, beginning with an oval that you divide with a cross (Fig. 126). You now have some guidelines with which to position the eyes, since they are situated half way up the head. The vertical line will help you position the nose and the other parts of the face, taking into account the symmetry of the human head seen from the front. These lines correspond to the *canon of the human head.*

**Canon of the human head**
Before drawing a head, a face, or a portrait, the artist must study the general dimensions and proportions of the human head. These proportions are determined by the *canon,* that is, a system which establishes the proportions and dimensions of the human face according to a basic measurement known as the module.

Figs. 129 and 130. The canon of the human head determines the position, the dimensions, and the ideal proportions of the parts of the face and the head. Naturally, these positions and dimensions do not coincide exactly with any or all real heads, as is evident by comparing th canon superimposed over an ideal face in Fig. 129 with that superimposed over Beethoven's head in Fig. 130. However, the canon is always a useful aid in boxing or in drawing initial sketch of the face.

The *canon* of the human head is largely studied in the book *How to Draw Heads and Portraits* in this same series.

# Stage two: calculating dimensions and proportions

131

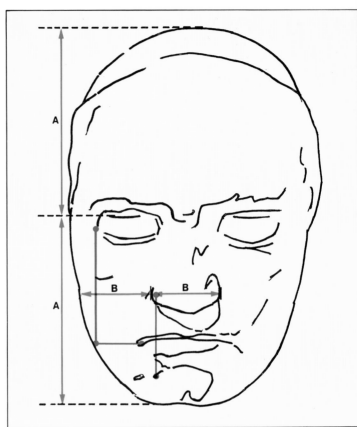

132

Calculating both dimensions and proportions—in other words, the art of drawing—basically depends on comparing forms, distances, and the length of some strokes in relation to others. For example, the red lines in Fig. 132 show that the eyelids are situated half way up the head (A) and that the base of the nose measures the same as the distance between the nostril and the edge of the cheek (B).

As your drawing progresses, you will need to check that your calculations of dimensions and proportions are correct. You can check this by using a series of imaginary vertical lines to help you verify position, shape, and distance.

This same exercise can be repeated using imaginary horizontal lines to check and adjust measurements. The blue lines in Fig. 132 indicate useful references when drawing a face: For example, a line extending from the corner of the eye forms a right angle with an extension of the corner of the mouth and a line extending from the nostril is perpendicular to the chin.

Now, using the charcoal unblended and working with oblique strokes (Figs. 133 to 135), draw the shadows on the model. Create contrasts by "painting in" the dark areas and leaving the lighter areas almost "unpainted." Remember that you can easily create the lighter tones later by using your fingers.

Figs. 131 and 132. Beside using the canon of the human head as a basis for my drawing of Beethoven's face, I have tried to establish some points of reference that will help me calculate distance and shape by using imaginary lines to situate points, outlines, shapes, as illustrated in Fig. 132.

# Stage three: using lines to box shadows

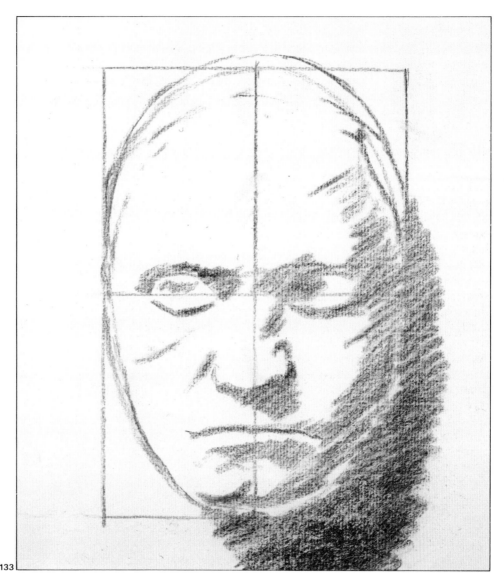

133

Figs. 133 to 135. Using the point of the charcoal stick (Fig. 134) or the charcoal in a flat position to sketch in larger areas (Fig. 135), I have made this initial drawing of the structure of the face (Fig. 133), in which all the shadows of the model are suggested by as-yet-unblended lines.

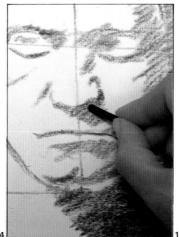

134

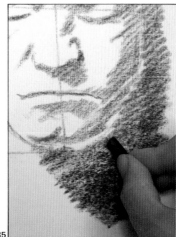

135

# Stage four: preliminary blending and progressive value

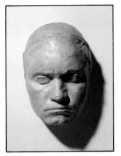

**136**

Figs. 136 to 139. I have arrived at what I consider to be a satisfactory stage (Fig. 137) for a preliminary drawing in which the charcoal pencil has not yet been used. So far I have only used charcoal, intensifying shadows and correcting forms, dimensions, and proportions (Fig. 138). I have alternated these strokes with others blended with the fingers (Fig. 139).

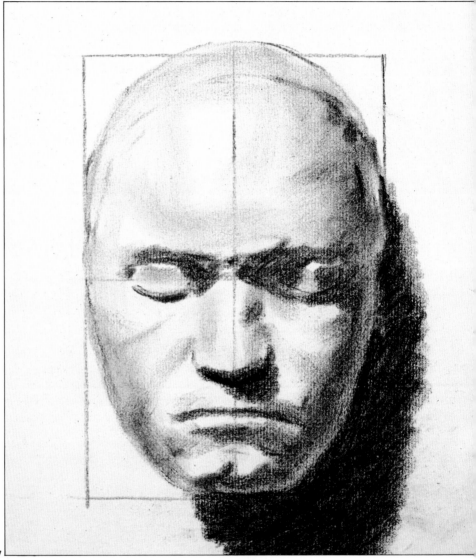

**137**

Now we will create shade and value with charcoal, blending with the fingers, but not yet using the eraser, to create tonal areas, while still working on contrast. Here you can apply what you learned earlier when you drew an apple and a sphere (pages 30 and 32) about creating gradations by passing your finger over the line and about lightening tones by gently brushing over them with one or more fingers more or less loaded with charcoal.

**138**

**139**

# Stage five: wiping out and reconstructing

Figs. 140 to 142. To eliminate the charcoal dust, I carefully wiped or patted the drawing with the cloth, endeavoring to retain the general structure of the drawing. Thus I have arrived at the stage illustrated in Fig. 140 ready to draw the final version in charcoal pencil.

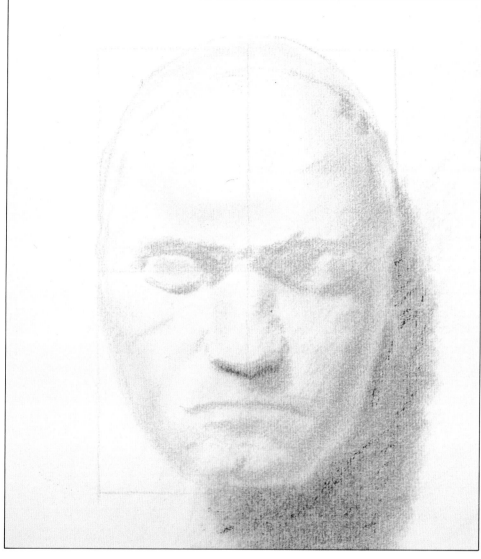

140

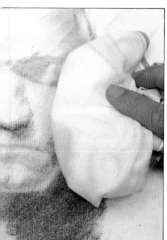

141

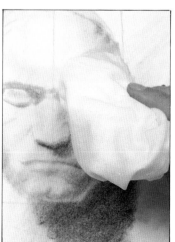

142

Gently dab or wipe the drawing with a cloth to remove the charcoal dust before starting your final drawing with the charcoal pencil.

If you are very satisfied with your drawing, wipe off less; otherwise, wipe off more. In any case, you can correct the drawing later, still using the charcoal to rebuild the drawing, if necessary.

# Stage six: drawing a final version in charcoal pencil

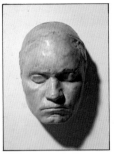

**143**

Figs. 143 and 144. Here we have the results of a painstaking process of drawing with a charcoal pencil and blending with both fingers and stumps. We have achieved a re-fined degree of drawing and shading, but the work still lacks contrast and definition of small details.

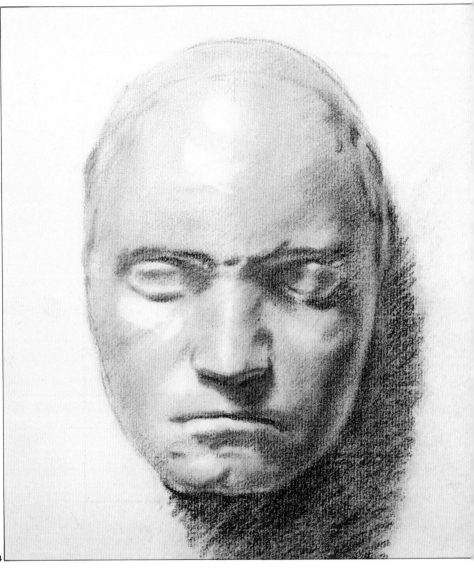

**144**

At this stage your drawing will have a grayish appearance, with faint contrasts, ideal for opening up bright areas with the eraser and for reinforcing and building up your drawing with charcoal pencil.

Proceed as follows: Start by *opening up white areas with the eraser,* confidently blowing away the rubbings at no risk to the drawing. Now use the sharpened charcoal pencil and patiently shade the drawing, *using tiny strokes, or working in a circular motion,* and *harmonizing.* Harmonizing is very im-portant for creating uniform grays and gradations.

Work "provisionally" for the time being, still restricting yourself to medium or slightly darker grays, without using the charcoal pencil to produce black areas. And no blending.

By this stage you should have a very confident drawing, incorporating all the appropriate light areas and reflections. Overall shading and treatment of shadow should be carefully worked into a predominantly light tone.

# Stage seven: blending and final shading

Figs. 145 to 147. In this penultimate stage, in which almost everything has been completed, we have darkened some areas and enhanced some forms with the charcoal pencil, blending and harmonizing the whole to achieve an academic drawing.

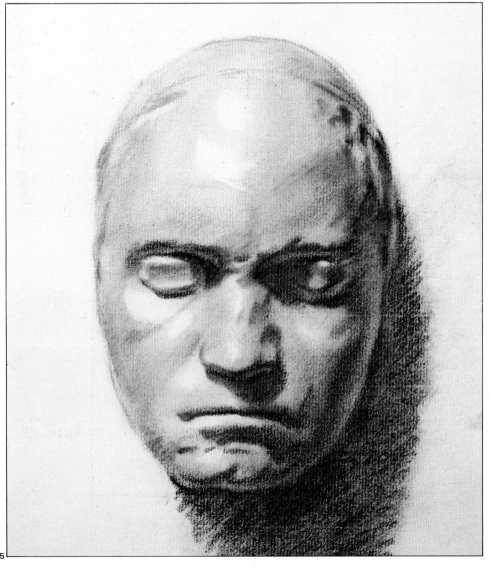

145

146

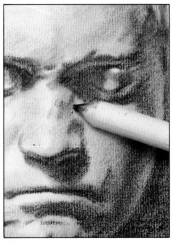

147

Now work slowly, shielding the drawing by placing a paper under your hand, using your fingers and paper stumps—including your own homemade sharp stump—and drawing in charcoal pencil, with very occasional use of the rubber eraser.

First, blend the darker areas; then clean the stump and work the lighter areas.

Take great care when you clean or change the stumps. Remember that you can blend very light areas with your fingers.

# Stage eight (the final stage): the finished drawing

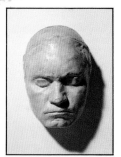

**148**

Figs. 148 to 151. I presume you have also been drawing Beethoven's mask. Now ask yourself if your drawing is too dark, if the contrast is right, if you have blended the contours, if the light areas you have drawn with the eraser are appropriate. And work on the drawing just a little more, until you're satisfied.

Technically, the final phase of the charcoal drawing is in every way comparable with the final stage of a lead pencil drawing. In regard to this particular medium, I would urge you:

> *Beware of excessive darkening. Maintain perfect balance in the shading.*

Create value with the following in mind: Be careful not to darken your drawing excessively, producing a sooty effect, but give full rein to your artistic flair in those areas that really require a rich black color. On the other hand, be careful with the *contrasts.* Remember that excessive darkening can result in a monotonous treatment of the dark tones, while an absence of dark tones is also equally undesirable. Look at the finished version reproduced on the following pages (Fig. 151). Notice the subtlety of shading in this drawing.

Don't use the eraser excessively for drawing light areas.

Finally, try to create *atmosphere,* eliminating any harsh, sharp edges and any exaggerated definition of outline. Gently blend these outlines, especially those which are in shadow, endeavoring to create a greater sensation of space, atmosphere, and depth.

Carefully put the finishing touches on your drawing and fix it.

Now you've finished. Congratulations.

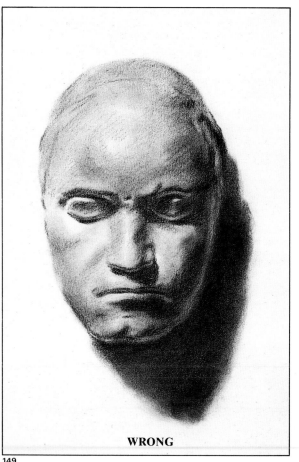

**WRONG**

149

**WRONG**

150

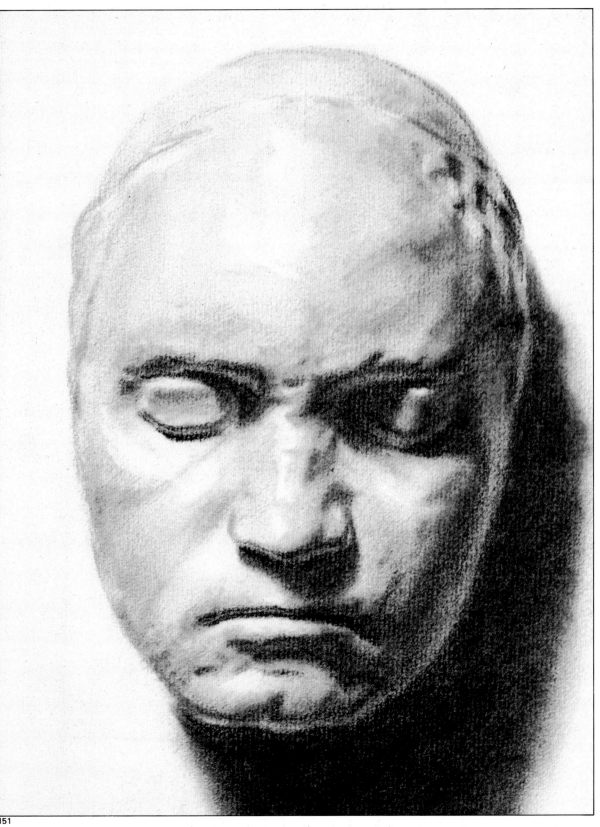

151

# What not to do when you are drawing with charcoal pencil

### Do not neglect details

Charcoal drawing is the first step toward painting. It satisfies our desire "to fill empty spaces quickly" without the laborious task of working with a lead pencil, which requires long and patient hard work.

But it is precisely for this reason that charcoal lends itself to "painterly" drawing, encouraging the artist to forego detail in favor of large patches of color, darkening, correcting, and creating effect.

In the hands of an expert, the factors and properties of the medium can produce a truly impressionist work, that is, a painted drawing where volume is achieved by means of "color"—by color we refer to the values suggested by the interplay of grays, whites, and blacks. However, in such a drawing, form will be properly rendered, with visibly defined detail. In a word, it will be the drawing of a professional who is in perfect command of the artistic means at his or her disposal and who achieves a perfect, if apparently unfinished, work.

To arrive at this expert knowledge, the professional artist will first have had to study drawing and precision of shade and form in a detailed, academic manner.

The characteristics inherent in charcoal—easy covering power and the ability to darken, fill in, and paint— are, in the hands of an amateur, treacherous enemies, luring the artist like seductive mermaids on to the rocks of an amateurish drawing.

### Strive for detail of form and shading

Bear in mind that forms are defined by tones, by light—bright light, not-so-bright light, dim light, and very dull light—but never by lines surrounding and framing shapes.

This takes us to the second part of this brief lesson on what not to do:

### Do not neglect tonal gradations

I'm sure you'll remember how to go about achieving perfect shading: Observe the tone, compare it with others, mentally classifying it according to a kind of tonal scale, and draw it, working carefully from light to dark. It would not be amiss to reiterate these general rules. Remember:

| WHEN CREATING VALUE | |
|---|---|
| **OBSERVE:** | **Observe** tone. |
| **Compare:** | **Compare** with other tones, both lighter and darker, in the same model. |
| **Classify:** | Mentally **classify** light, medium, dark gray within a general scale of tonal values. |
| **Draw:** | **Draw** by a process of comparison with the tones already drawn. |

By following these rules, you are unlikely to fall into the common trap of excessively dark shading, which the extraordinary ease of drawing with charcoal pencil tends to encourage. With time—since you will be forced to work more slowly—you will make a timely discovery: It is a mistake to use excessive or unbalanced shading in rendering the model you have before you. Fundamentally, it is a question of always comparing, time and time again, when you begin or finish a drawing.

Fig. 152. The volume represented in the figure study by Miguel Ferrón comes from the wide range of tones that vary from deep black to light gray and white. These values are the result of observing and comparing a precise tone with a darker one and a lighter one considered in the general scale of values.

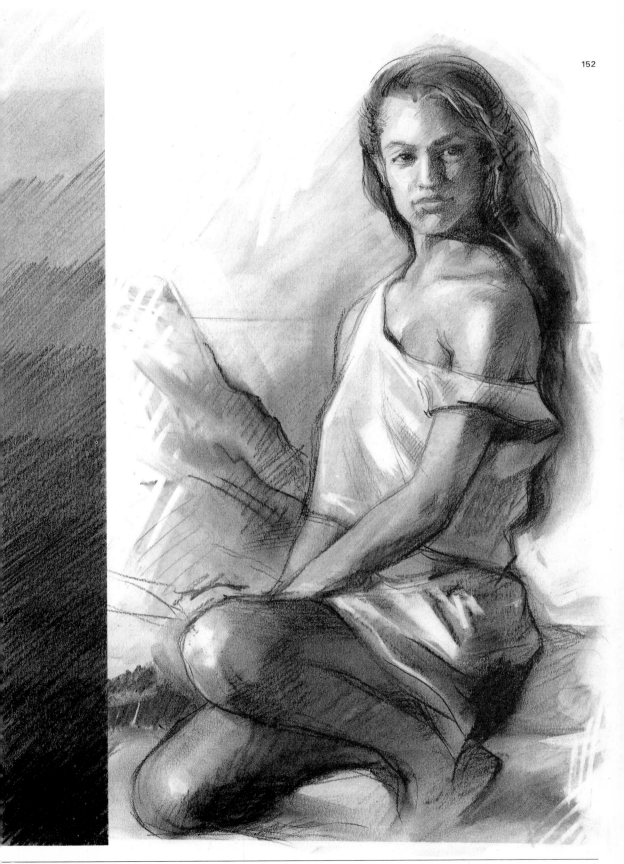

152

Sanguine is a pigment made of iron oxide and chalk. It is known to have existed for thousands of years and was used by the ancient Egyptians in their hieroglyphics and burial chamber paintings and also by the Romans in the frescoes that decorated their walls. During the early Renaissance (1420-1500), very few artists practiced sanguine drawing, preferring charcoal and black chalk, which were more stable and less glaring than the red of sanguine. But around 1480, fixative liquid was discovered, and Leonardo da Vinci explored the properties and potential of sanguine drawing, achieving such good results with this medium that his example was swiftly followed by later Renaissance artists such as Michelangelo, Raphael, Correggio, Pontormo, Andrea del Sarto, and others. The use of sanguine as a drawing medium will be discussed on the following pages.

153

# SANGUINE
# DRAWING

# Some examples of sanguine drawing

As these drawings show, sanguine is an ideal medium for figure drawing, especially for sketches and studies of the nude. On white paper and even more so on cream-colored paper, where bright areas, highlights, and reflections are picked out in white chalk, sanguine offers the possibility of drawing and simulating the color of flesh with a wealth of subtle nuances that no other drawing medium can provide. On this and the opposite page are some examples of sanguine drawing by various artists of different periods—from the Renaissance to our own times.

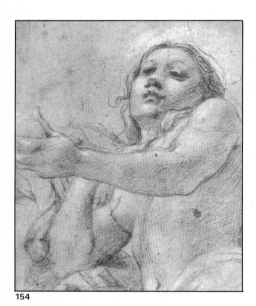

154

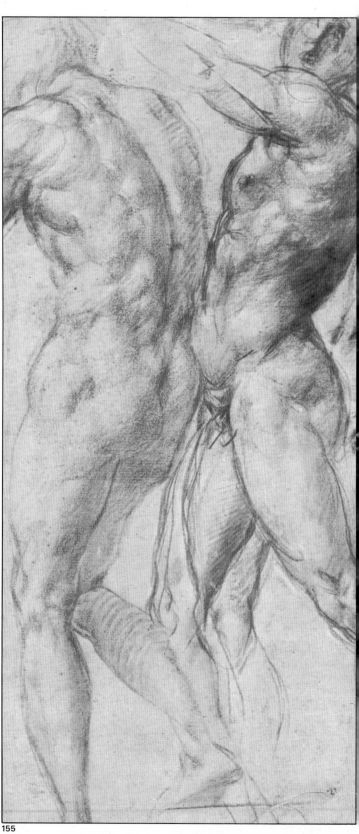

Fig. 154. Antonio Correggio (1489-1534), *Eve* (detail), sanguine enhanced with white chalk, Cabinet des Dessins, Louvre, Paris.

Fig. 155. Pontormo (1496-1556), *Three Men Walking, Study,* (detail), sanguine, Museum of Fine Arts, Lille.

155

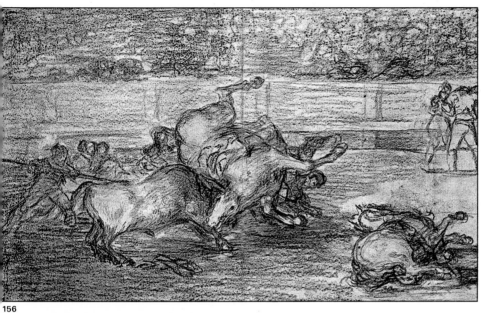

156

157

158

Fig. 156. Francisco de Goya y Lucientes (1746-1828), *Rider Toppled by Bull,* sanguine on white paper, the Prado, Madrid.

Figs. 157 to 158. J.M. Parramón, *Head of Socrates* and *Portrait of Marisol,* two sanguine drawings, the first on cream-colored paper, the second on white paper.

# The techniques of sanguine drawing

Sanguine bars, sanguine sticks, sanguine powder, and sanguine pencil.
Hard sanguine, soft sanguine, English red sanguine, crimson and sepia sanguine.
Sanguine for drawing on white paper or on colored paper, enhanced with white chalk.
A pleasing medium, sanguine can be used to create a surprising range of tone and shade, especially in portrait and nude figure drawing.
The technique for sanguine drawing is basically the same as that for charcoal and its derivatives: You draw with a piece of a bar or stick, holding it in the usual way for drawing lines, as shown in Fig. 160. You can also draw with a flat edge of sanguine to produce value and shading with broad strokes (Fig. 161).

Sanguine can be diffused with a stump or with the fingers, creating soft, delicate tones to give value to very light, flesh-colored areas, as on the face.
As in drawing with charcoal and its derivatives, you can use a stump loaded with sanguine to draw strokes, to shade large areas, and to create progressive value.
Drawings of a quality similar to those of pastel paintings can be achieved by using a wide range of sanguine colors, from natural sienna to dark sepia, including English red and terracotta, plus black and white chalk and colored paper.
Sanguine, and indeed all the colors in the sanguine range as well as white and black chalk, can be diluted with water to produce color washes similar to those of watercolors.

Fig. 159. The materials you will need include white paper, ochre-colored paper, gray paper, a sanguine bar, and a sanguine pencil. Sanguine often comes in English red. When drawing on colored paper, highlights are usually picked out in white chalk and blended with the fingers or with a stump. One interesting aspect of this medium is that sanguine can be diluted with water to produce washes similar to those of watercolors.

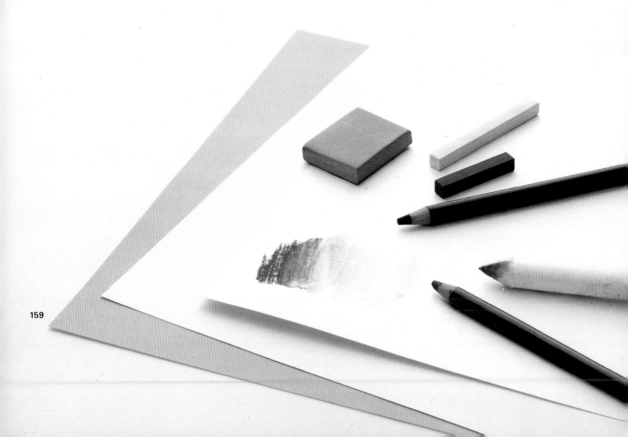

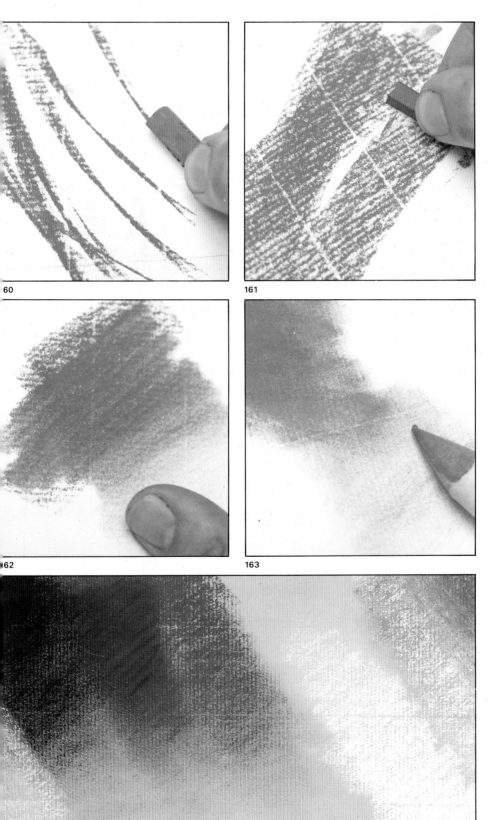

60

161

62

163

164

Fig. 160. Lines and strokes can be drawn with the edge of a piece of sanguine stick as illustrated here and as we shall see in one of the exercises described later in the book.

Fig. 161. Hold the end of a sanguine stick flat against the paper, and you can draw thick strokes to cover very wide areas in a short period of time.

Figs. 162 and 163. Fingertip and stump blending, alternately, are both good ways of spreading and blending strokes and shading areas drawn in sanguine.

Fig. 164. In this illustration, you can see some examples of the effects achieved by mixing sanguine and white chalk and by combining sanguine and sepia on gray-colored paper.

# A half-body portrait in sanguine
# Artist: Miquel Ferrón

165

Fig. 165. This is Miquel Ferrón, our guest artist, who is going to draw a portrait in sanguine for us.

166

167

169

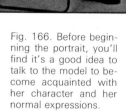

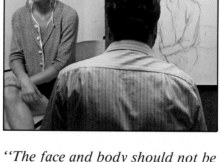

Miquel Ferrón, who teaches drawing at the Massana School, one of Spain's leading fine arts schools, is going to draw a half-body portrait in sanguine on cream-colored paper enhanced with white chalk. The model is Ana, a pretty, blond-haired woman.

First, Ferrón gets to know the model—her personality, her characteristic expressions, her facial movements, the expression of the eyes, the way she laughs and listens. He talks to her for some time, continuing his "interrogation" as Ingres called it, studying and varying the pose, looking for the most pleasing artistic composition. Refer to the model's pose in the adjoining figure (169), which shows Ferrón making a sketch, and the sketch in Fig. 171 on the following page, and notice how the head faces in the same direction as the body in a pose that is not very pleasing aesthetically, especially when compared with the poses in the other two sketches (Figs. 170 and 172). The latter follow the advice of Ingres:

Fig. 166. Before beginning the portrait, you'll find it's a good idea to talk to the model to become acquainted with her character and her normal expressions.

Figs. 167 to 169. Ana, the model, poses for the artist.

Figs. 170 to 173. Ferrón studies the pose by drawing a series of sketches before beginning the portrait.

*"The face and body should not be turned in the same direction."* The model's pose is more artistic in these sketches.

Ferrón finally chose the pose in Fig. 173, which corresponds to the last of his series of sketches (Fig. 172).

# Preliminaries: "interrogating" the model through a series of sketches

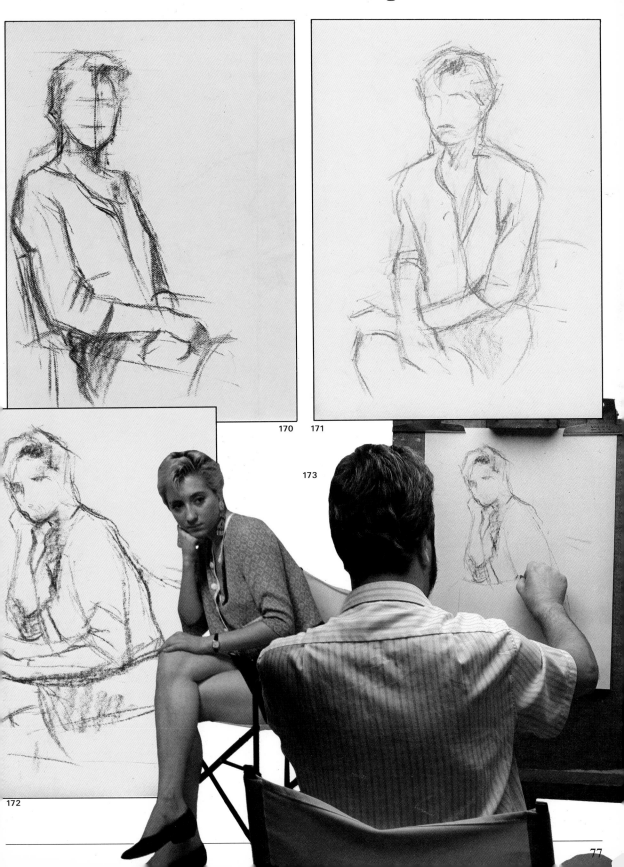

170    171

173

172

# Stage one: materials and preliminary structure

Fig. 174. This is the pose Ferrón has selected for his half-body portrait of Ana.

174

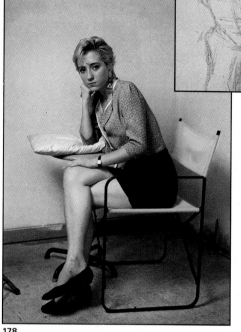

At the bottom of this page, in (Fig. 178), you can see a photograph of the materials Ferrón used. In addition to the chalks and pencils in sanguine, both sepia and white, the stumps, the cloths, and the common rubber eraser, notice the white pencil (the second from the left), which, in

177

175

176

Fig. 175. Ferrón begins his drawing, basing it on the canon of the human head.

Fig. 176. In this preliminary, unshaded sketch of the half-body portrait, Ferrón used only lines for the basic structure.

Figs. 177 and 180. Here he starts work on the portrait, building the features of the face, which are still in a rudimentary phase.

Fig. 179. Now Ferrón partially wipes out the original drawing with a rag. Next he will begin to redraw, re-creating the likeness.

178

**THE DRAWING
MATERIALS
USED IN A
HALF-BODY
PORTRAIT IN
SANGUINE**
(From left to right):
An ordinary rubber
eraser.
An eraser in pencil form.
Stump.
Colored chalk pencils:
white, sanguine, sepia,
and black.
Colored chalks:
sanguine, black, white,
and sepia.
A rag for wiping out
and blending.

179

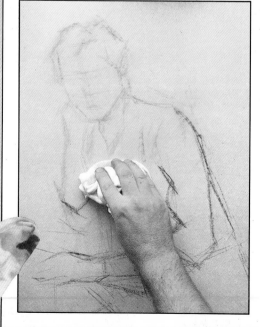

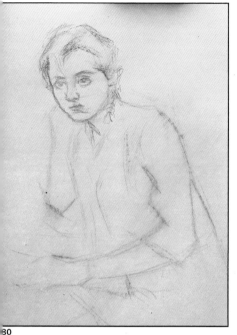

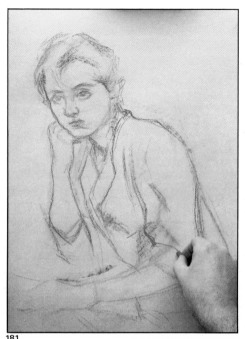

Figs. 181 and 182. Here you can see the final process in this first stage. After drawing greater definition of the head and the body (Fig. 181), Ferrón begins to build value into the portrait, capturing effects of light and shade (Fig. 182).

fact, is an eraser in the form of a pencil, which is used for "drawing" small white areas and reflections.

Ferrón starts work on the portrait, drawing with a piece of sanguine-colored chalk, working out the position of the eyebrows, the base of the nose, and the chin, basing his calculations on the measurements of the canon of the head (Figs. 175 and 179). Then he sketches the rest of the figure, erasing, or rather attenuating the line (Figs. 176 and 179). Going over the drawing once again, this time he gives definition to the head and the face (Figs. 180 and 181). He redraws the body, using lines to construct it (Fig. 181), and reinforces the strokes, virtually finishing the line drawing.

Finally, he sketches a few shadows, using the flat edge of a piece of chalk, and moves on to the next stage (Fig. 182).

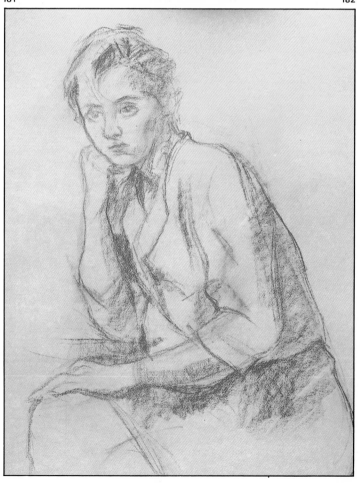

# Stage two: drawing the face

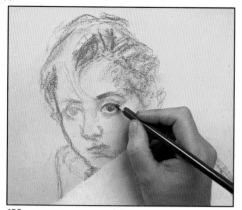

183

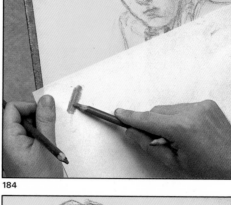

184

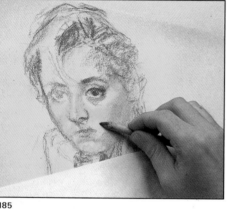

185

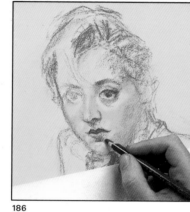

186

Fig. 187. During the initial stage of the portrait (preceding pages), Ferrón worked with the drawing board and paper resting on an easel in a vertical position. Now, in the second stage of the drawing, he works with the board resting on his lap and propped up against a stool at a 45 degree angle for greater ease in drawing the head and features of the face. Moreover, this position enables him to take in the model and the drawing at a glance, without having to move his head.

Fig. 188. As he builds and gives definition to the left eye, Ferrón bears in mind Ingres rule: "The distance between one eye and the other is equal to the width of one eye."

Fig. 189. Here Ferrón uses the pencil eraser to "draw" white areas and reflections on the face.

Fig. 183. Ferrón now reaches a more delicate stage in the drawing, working with a paper under his hand to protect the drawing from smudges.

Figs. 184 and 185. Here you can see the trick Ferrón used to draw soft tones and shadows: First, he draws some heavy strokes with a sanguine-colored chalk pencil (Fig. 184). Then, he picks up the color with a stump, using it to paint (Fig. 185).

Fig. 186. Now Ferrón draws the mouth, leaving the drawing of the other eye until a little later.

So far, Ferrón has used the drawing board and paper in an upright position on an easel. But now he is going to draw the head and the face, so he rests the drawing board on his lap at a 45 degree angle, using a stool as a support (Fig. 187). He continues to work at a distance of just over 6 1/2 ft (2 m) from the model. Notice another detail, illustrated in the adjoining figure (left). Ferrón's position, together with the position and angle of the drawing board in relation to the model, enables the artist to see at a glance both the drawing and the model without having to move his head. Another factor to be considered is that Ferrón works with a paper under his hand to protect the drawing from smudging. Taking this precaution and drawing for the first time in sepia-colored pencil,

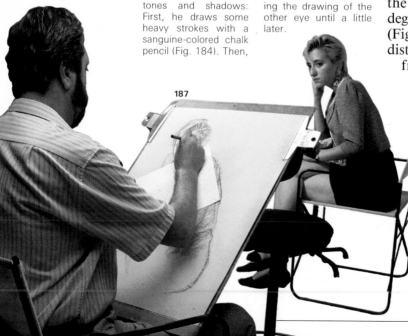

187

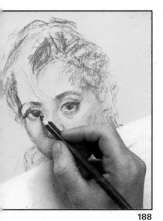

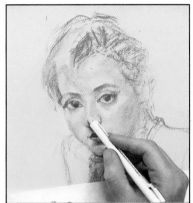

188    189

When he has finished this stage (Fig. 192), Ferrón shows the drawing to Ana, who exclaims, with a surprised smile, "Yes, that's me!" Ferrón's drawing reminds me of a sanguine portrait of Hélène Fourment, the wife and model of Rubens.

Figs. 190 and 191. Ferrón blends alternately with stumps and his fingers. He uses the latter for working on large areas of the face.

Fig. 192. At the end of this second stage, we can appreciate the qualities, the subtle nuances, and richness of color achieved only using sanguine and sienna, together with the background color of the drawing paper.

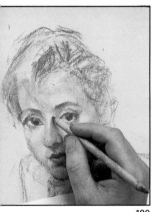

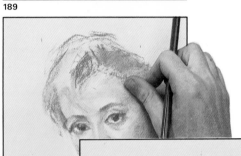

190    191

Ferrón begins work on the right eye (Fig. 183). Then he works on all parts of the drawing, flitting here and there, following the advice of Ingres, without pausing or lingering too much over any one detail. Figures 184 and 185 illustrate another important lesson: Ferrón uses a corner of the protective paper to draw bold, heavy strokes of sanguine, from which he then loads the stump with color and uses it to draw medium tones as he models the face. Then he uses a dark sepia, drawing the left eye and then the mouth (Fig. 186). Now the time has come to "draw" with the pencil eraser, opening up a light area here, reducing a tone there, giving greater definition to a form or a reflection (Fig. 189). This is also the stage at which Ferrón relies on the stump, loaded with sepia. Ferrón blends alternately with the fingers—mainly the thumb—and a stump to harmonize larger areas (Figs. 190 and 191).

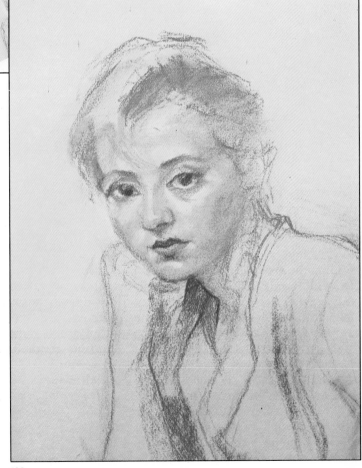

192

# Stage three (the final stage): the finishing touches

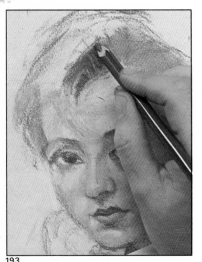

193

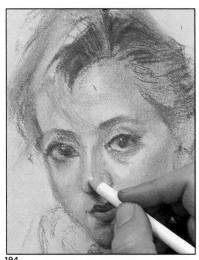

194

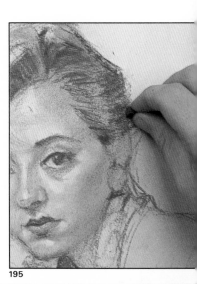

195

Ferrón proceeds according to Ingres' basic rule, which states that "the essence of the finished drawing must be inherent even in its initial expression: all parts of the drawing must be worked on in such a way as to make it viewable at whatever stage in its execution, at all times resembling the final perfected version."

This final stage, in which the drawing is perfected, begins with a series of strokes using a sepia-colored pencil to give definition to the model's hair (Fig. 193). Then, using a white chalk pencil, he picks out the white areas and the highlights (Fig. 194). Next, he reinforces the lines that give shape to the hair, using sepia-colored chalk, drawing in a spontaneous, energetic way with the flat edge of the chalk (Fig. 195).

Now, he moves to the body (Fig. 196). Holding the pencil inside the hand, he draws at arm's length, holding his body erect, trying to maintain a global view, conceiving and working on the composition as a whole, in which no single element upsets the overall balance.

It's almost finished. He works slowly, calculating every move and every stroke. He decides to give some more attention to the arm and the hand on which the model's chin is resting. He gets up and puts the drawing board

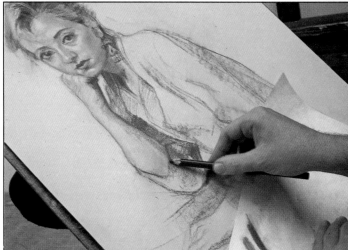

196

back on the easel in an upright position. He looks at it, studies it carefully, and thinks out loud, "I don't think the body and the dress need much more attention—just a few touches, a few soft tones to add definition." He takes the rag, and wrapping it around his index finger, he blends a few patches, lines, and shadows. "That's more or less right, I think," he adds. And he stands back and looks at it. "I've finished!" he says, and he signs the drawing.

Figs. 193 to 195. Ferrón finishes drawing the head and the features of the face, as he tries to perfect the artistic quality of the drawing.

Fig. 196. When drawing the head and features of the face, Ferrón always held the pencil in the usual way. But now, to give definition to the

shape of the body, he draws with the pencil inside the hand for greater ease in making broad strokes.

Fig. 197 (next page). For deeper blending of form and value on the body and the dress, Ferrón uses the rag on his index finger, as illustrated in this picture.

Fig. 198. In my opinion Ferrón's drawing fulfills the two basic requirements stressed by Ingres in his advice to students about portraiture: "It must be an exact likeness and have great artistic value."

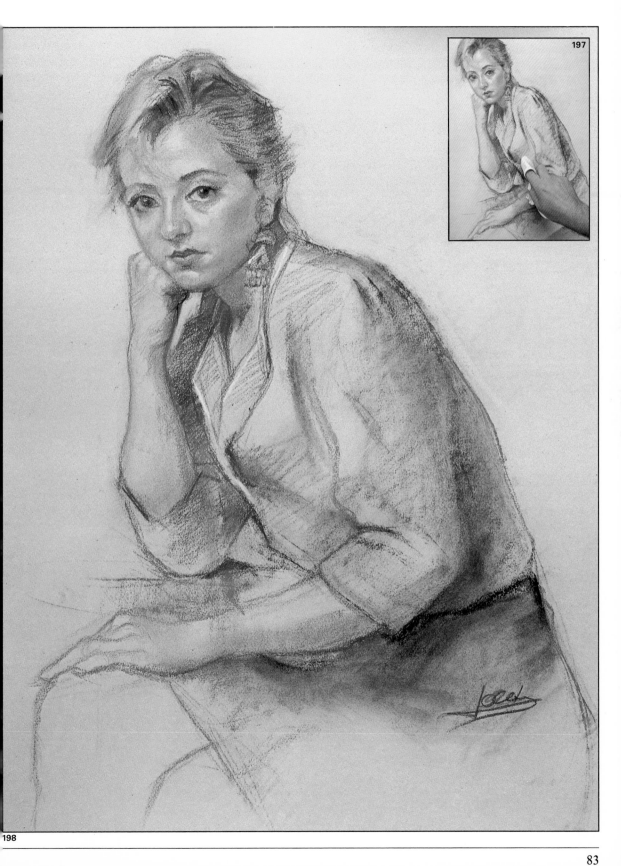

197

198

Now we come to the last chapter in the book. This is where the great attraction lies, the fascinating adventure of drawing and painting at the same time, of *painting drawings* using all the materials: charcoal, carbon, sanguine, chalks, colored paper, stumps, the fingers, a cloth, cotton wool, and a kneadable eraser.

We take up the challenge on the following pages, by looking at the work of others, followed by a visual study of the combined technique and three practical exercises arranged in order of difficulty: a still life, a figure study, and a self-portrait. I hope you will do a self-portrait by yourself at home, relying on what you have learned from this book and using all your artistic and creative talent.

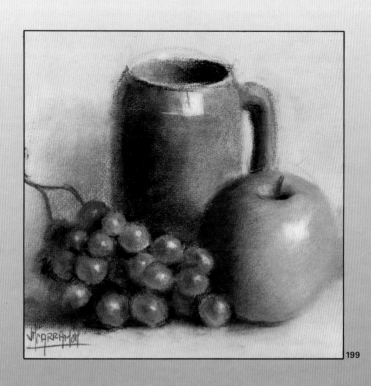

199

# CHARCOAL, SANGUINE, AND CHALK: PRACTICE IN COMBINED TECHNIQUES

# Examples by the great masters

On these pages you can see some magnificent examples of drawings using combined technique on colored paper and in charcoal, carbon, and colored chalks enhanced with white chalk. Let me draw your attention to the following interesting points: Le Guide drew this *Head of a Young Man* (Fig. 200) at the beginning of the 17th century, by which time painting in sanguine and black and white chalk on colored paper was a common practice among artists of the age, although these works were conceived as paintings rather than as drawings. A hundred years later, at the height of the Rococo period, Greuze and Boucher, among others, were pioneering the technique of *dessin á trois crayons,* using carbon or black chalk, sanguine chalk, and white chalk on colored paper (Figs. 201 and 202). In the 19th century, in the mainstream of Classicism and Realism, Pierre-Paul Prud'hon reinterpreted classical poses and figures, drawn in the academic style using black and white chalk on blue-gray paper (Fig. 204). Finally, we have an example of a drawing by Franz von Lenbach, painted in colored chalks (or pastels) on paper he made himself.

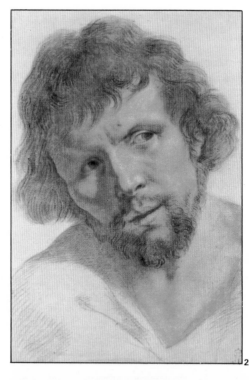

200

Figs. 200 to 202. Le Guide (1575-1642) *Head of a Young Man* (detail), The Hermitage, Leningrad. Jean Baptiste Greuze (1725-1805) *Head of a Young Woman* (detail), Cabinet des Dessins, Louvre, Paris. François Boucher (1703-1770), *Young Woman with a Flower,* private collection.

202

201

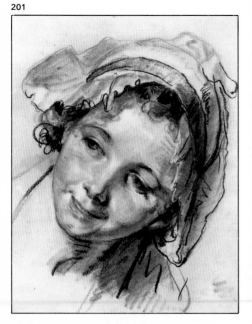

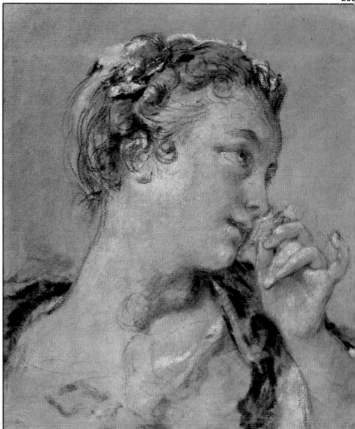

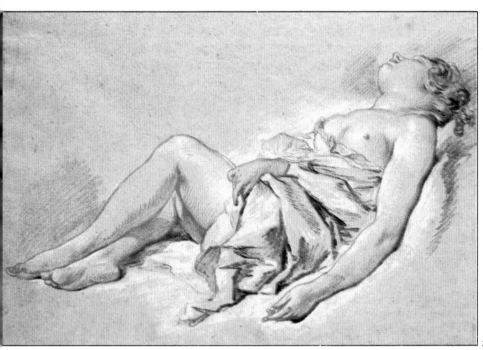

Figs. 203 to 205. François Boucher (1703-1770), *Young Woman Sleeping,* private collection. Pierre-Paul Prud'hon (1758-1823), *The Drinking Fountain,* Clark Art Institute, Williamstown, Massachusetts. Franz von Lenbach (1836-1904), *Young Woman Holding a Fan,* The Hermitage, Leningrad.

203

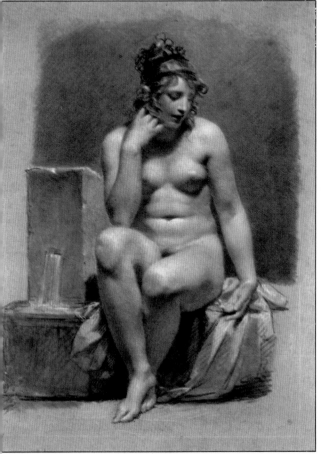

204

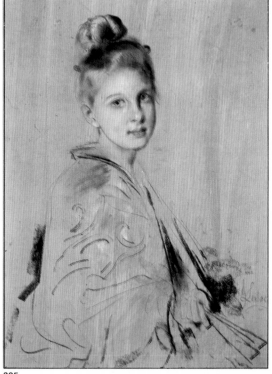

205

# The possibilities of the combined technique

The technique used in drawing with charcoal and, more especially, charcoal derivatives has a general, practical application to drawing in chalk on colored paper. We can use sanguine or any other colored chalk to paint gradations using either our fingers or a paper stump, bearing in mind earlier comments on charcoal pencil techniques (page 50). That is, we need to draw the shading lightly in chalk and then blend with a stump (A); we can also paint progressive tones without blending (B).

Mixing two or more colors with white chalk on colored paper, we can achieve excellent results comparable with those of a pastel or an oil painting. But we are concerned with the use of drawing techniques to create paintings, and we will therefore aim to produce works in which *the art of drawing* predominates. This concept is illustrated in Fig. 208.

The basic color of the apple—like the skin and flesh tones in the examples on pages 86 and 87—is provided by the color of the paper. Then, sanguine, ochre, and white chalks are used to create effects of light and shade, as well as volume. So the drawing is a drawing, not a painting, as demonstrated by the combined technique using colored chalks.

Figure 207 shows an example of a drawing in colored chalks to which a wash was then applied with a brush, treating the chalks as if they were watercolor pencils diluted with water. We do not recommend this technique, but it certainly is another possibility for creating painted drawings with charcoal, carbon, and colored chalks.

Figs. 206 to 208. On this page you can see some practical examples of using the combined technique. If you practice these exercises, I am sure you will achieve interesting results of your own by combining a variety of materials.

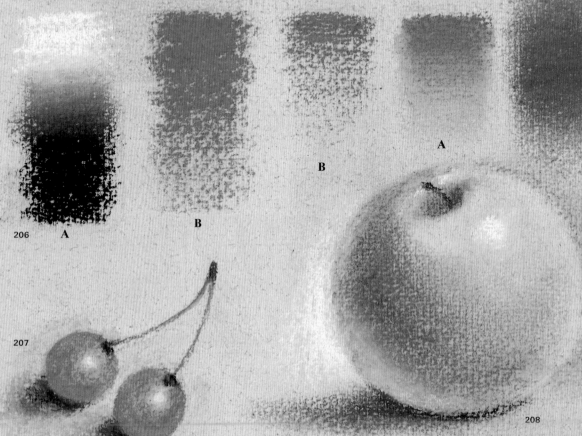

206  A
  B
B
A
A
207
208

# Drawing a pottery still life using a combined technique
## Stage one: building with charcoal

Here I am in my studio. As an example of combined technique, I'm now going to draw a still life consisting of various pottery objects and an apple, using charcoal, charcoal pencil, and colored chalks on colored paper. I'll work with the color ranges mentioned and illustrated on page 14 (the black, gray, and white selection and the ochre, sienna, and sanguine selection). The model will be illuminated from the front and side with an artificial light (Fig. 210).

Using a yellow-ochre Canson Mi-Teintes paper, I begin to build and draw the still life, working exclusively with charcoal. From the very first strokes, I try to represent the model's structure through light and shade, thus reproducing its volume, remembering always that the contours of objects are not suggested by *lines,* but by *tones.* This lesson was summed up by the American teacher and painter Thomas Eakins (1844-1916) when he wrote: "There are no lines in Nature; only color and form."

I conclude this first stage by fixing the charcoal drawing.

209

Fig. 209. The author, José M. Parramón, as he begins to draw a still life composed of various pottery objects and an apple.

Fig. 210. This is the model: various receptacles, a plate, a few brushes, and an apple. The range of colors is suitable for drawing in the combined technique.

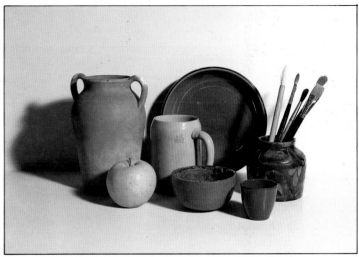

210

Fig. 211. This is how the drawing on yellow-ochre paper looks at the end of the boxing-up stage, incorporating tones, lights, and shadows.

Fig. 212. The charcoal drawing is fixed to protect the original drawing and tonal values.

211

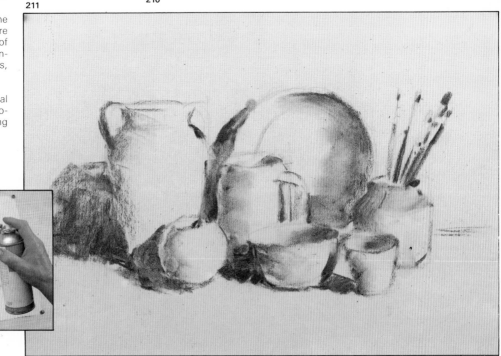

212

# Stage two: the first coat of color

Figs. 213 and 214. I start by painting the first coat using sanguine, sienna, and ochre chalks over the fixed charcoal drawing.

Fig. 215. Using the flat edge of a piece of orange-ochre chalk, I color in the table or surface on which the model is standing.

Fig. 216. Then I cover the background in white chalk, spreading and blending with a wad of cotton wool instead of a stump. Cotton wool is very effective when painting large areas of uniform color.

Fig. 217. At the end of this second stage, we have a preliminary, unfinished draft, with rather flat coloring, which still lacks tonal value and massing, as well as contrasts, but which nevertheless invites us to continue painting and building volume, enhancing the illuminated parts and intensifying the shadows.

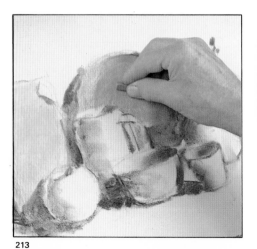

213

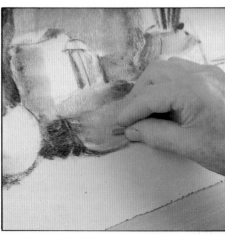

214

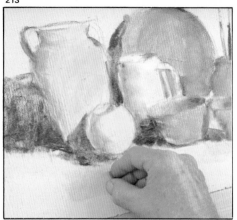

215

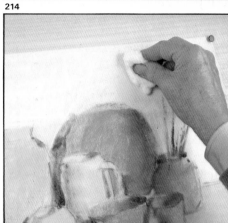

216

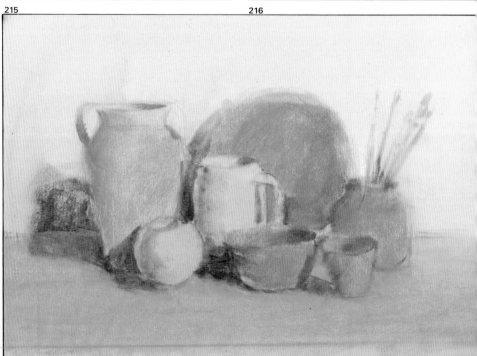

217

# Stage three: value and subtlety of color

In the preceding stage, I applied the first coat of color to the composition, including the background or table on which the model is placed. As yet, volume and contrast are still suggested by the original charcoal drawing over which I have painted the colors of the pottery objects, the plate, and the apple, with hardly any value and without emphasizing the effects of light and shade.

In this third stage, I now create value and correct color and form. Working with a stump and my fingers, I begin to create contrasts by darkening the shaded areas with charcoal pencil and black chalk (Figs. 218 and 219). Using black to paint shadows may not appear very logical from the point of view of painting, since all shadows contain an element of blue. But at the moment we are working on a drawing *painted in chalks,* and it is vital to stress its *identity as a drawing* by using black. If you compare the drawing at this stage (Fig. 220) with the model reproduced on page 89 (Fig. 210), you will see that while the shapes of the objects in the real image have hard, definite edges

and outlines, those of the drawing are characterized by softer, less clearly defined outlines, thus appearing warmer and less mechanical. This brings me to another point: Fingertip blending is always more effective precisely because it is impossible to achieve such concrete, definite forms as those obtained by using a pointed stump.

Fig. 218. As a general rule, it is better to use the fingertips rather than the stump for blending. The fingers are more intimately in contact with the work and produce a more spontaneous result, since fingertip blending is less precise and definite than blending with the stump.

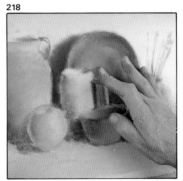
218

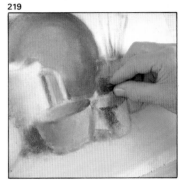
219

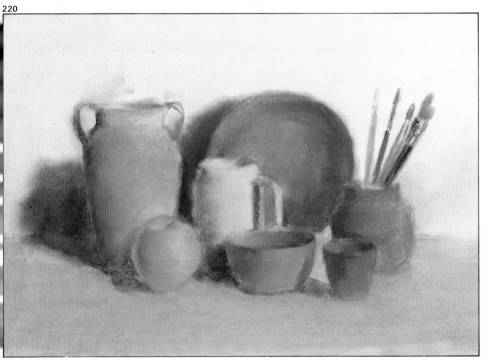
220

Fig. 219. Shadows can be intensified and darkened by using charcoal pencil or black chalk. Remember that the latter is softer and more versatile and creates a wider range of blacks and grays.

Fig. 220. The drawing has taken on a completely new look. During this third stage, I have addressed the model's form and color, balancing and correcting the color, checking and adjusting forms, combining the skills of a draftsman and a painter.

# Stage four: intensifying color and emphasizing contrast

Now is the time to adjust contrasts and volumes. We are about to begin the final stage, when the finishing touches and those last few minor corrections to shape or color should be carried out with great care and precision, both to avoid spoiling the drawing and to maintain value and coloring.

While we are on the subject of putting the finishing touches to the drawing with the stump, and particularly when using the fingers, it is important to be scrupulous in your work, cleaning your fingers with a cloth from time to time so as not to mix or smudge colors with them.

It is equally important to remember that a clean stump or finger will also remove color, thereby lightening the tone, if allowed to come in direct contact with an area painted in chalk.

When it comes to color, I want to mention those used in this composition. The earthenware vase behind the apple was painted in sanguine, yellow ochre, light gray in the area next to the apple and on the inner rim of the vase, and black in the shaded areas. The apple was done in yellow ochre, orange ochre, sanguine, and black. The beer jug was rendered in tones of light and medium gray and black. The plate in the background and the jar on the right containing brushes were drawn mainly in dark sepia, sanguine, yellow ochre, and black. The bowl and the tumbler in the foreground were painted chiefly in sanguine and black.

221

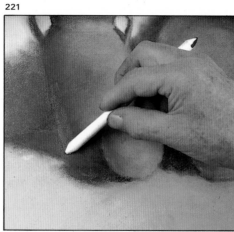

Fig. 221. A clean stump or finger applied directly to an area painted in colored chalk will automatically reduce and lighten the color.

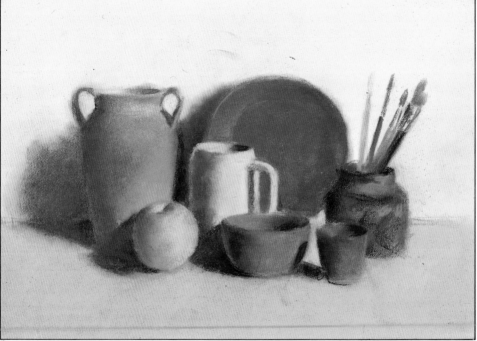

222

# Stage five (final stage): emphasizing form, reflection, and the finishing touches

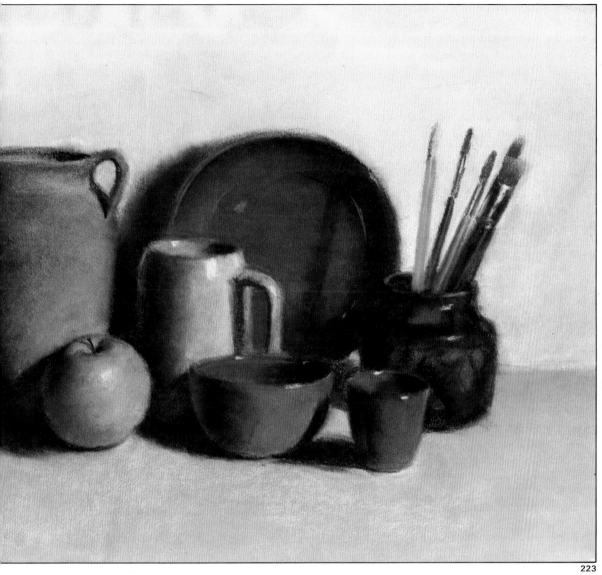

223

In addition to placing points of light, the final stage consists of a general revision of color and form. Compare for yourself the final stage and the previous one, observing how I have cleaned up the background by rubbing and wiping it with cotton wool, thereby reducing the effect of the white chalk and partially uncovering the ochre color of the drawing paper. I have reduced the bright ochre of the table and the orange yellow in the foreground by applying white and light gray. I have generally emphasized the darker shaded parts with black chalk,

blending and softening shapes and outlines as in the base of the beer jug, the apple, and the jar containing brushes in front of the plate. I have adjusted the tones and colors in some of the reflected shadows and reworked the brushes as well as the shapes and colors of the jar in which they are standing. And finally, I have adjusted the bright areas adding accents of white. That is all. Now you can begin drawing a still life in colored chalks like this one or use a model of your own choice. If you decide on the still life drawing, you can use the model of page 111.

Figs. 222 and 223. The intensification of color and contrast is obvious in this reproduction of the fourth stage (Fig. 222). But this process is more thorough and successful in the final stage (above) where I have made a complete revision of color, contrasts, and reflections and finally emphasized the bright areas. Lastly, I applied a light coat of aerosol fixative.

# A nude drawn in combined technique
# Artist: Joan Sabater

224

Joan Sabater, a fine arts graduate and teacher of drawing who specializes in painting the human figure, is going to paint for us a female nude, using charcoal, sanguine, and sepia-colored chalk in stick and pencil form, in addition to violet, pink, white, and black chalks on white Ingres paper. Sabater will also make use of stumps, a cloth for blending, and an ordinary rubber eraser.

He has placed the wooden drawing board with his drawing paper clipped to it on his studio easel (Fig. 224). Beside him on an auxiliary table, a case of Faber colored pastels, a brand of pastels whose gradations, although soft, are similar to that of colored chalk.

Joan Sabater works standing up. This is because he moves about a lot while he works, coming up close to the drawing and then leaning back from it, squinting with his head thrown back, constantly studying and comparing effects, values, and contrasts (Figs. 225-226).

225

Before starting to draw, Sabater talks to his model and shows her several sketches done the previous day (Figs. 228-230). He prepares the pose and the drawing he is going to work on today. Then, Sabater frames the model, using his hands to form a rectangle through which he views her (Fig. 231). "The model's pose is of fundamental importance," remarks Sabater before he begins work. "A large part of the work's success depends on the pose. A strange, forced, ungraceful pose can detract from the artistic value of the drawing and have an adverse effect on the appraisal of the work's merit. It is important to work with professional models who know what they are doing and who are used to adopting artistic poses. It is also necessary to study the pose in a series of preliminary sketches. For this drawing I made three sketches (Sabater shows me the three sketches reproduced in Figs. 228 to 230; the model for the sketches was not

the same as for the drawing). So I discussed these positions with the new model, and finally I selected this pose" (Fig. 232 on page 96).

22

Figs. 224 to 226. Joa Sabater draws a nude using a combined tech nique described on thes pages.

Fig. 227. Sabater talks t the model before begin ning his drawing.

Figs. 228 to 231 Sabater studies the pos by means of variou sketches and decides o a final one after framin the model with hi hands.

227

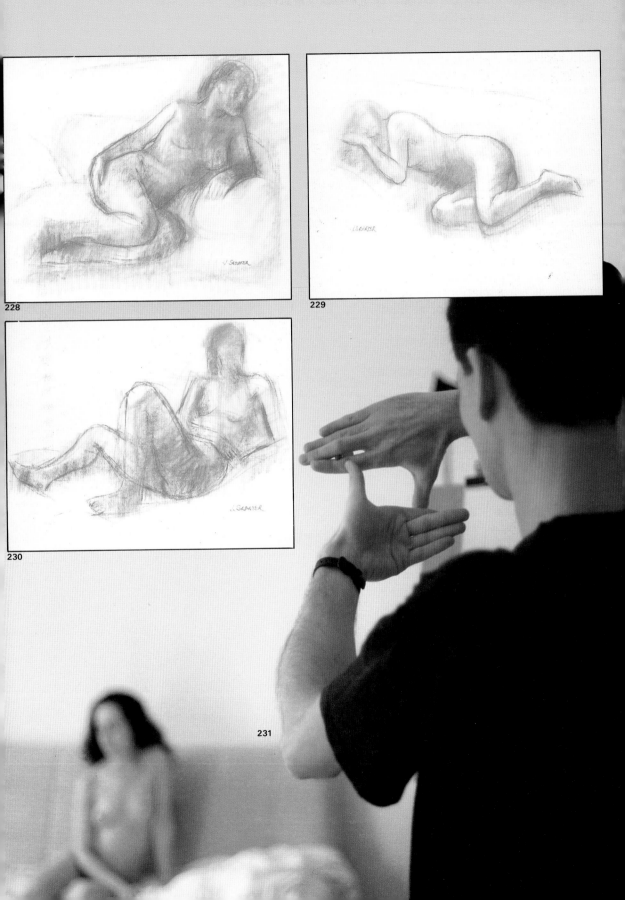

228

229

230

231

# Stage one: a good drawing

The model is ready: She has adopted a classic pose, seated with her face in a three-quarter position and her body resting on her left arm, her legs folded back, with a marked foreshortening of the right leg (Fig. 232).

Sabater starts to draw with a sanguine-colored chalk, which he holds flat against the paper in a vertical position, "turning the stick" to find the best edge for drawing a clear, thin line (Fig. 233).

He can also use the chalk in this position to draw tones and shades, drawing broad, sweeping strokes with the stick in a horizontal position. He blends with his fingers or a medium-sized stump, using short, rapid movements and shading in large areas of volume without bothering for the time being about the specific effects of light and shade.

"I alternate using the stump and my fingers," explains Sabater, "because, as you know when you are continually and vigorously blending a large area, the friction against the paper produces a burning sensation in your fingers."

I asked him why he uses a rag and, in particular, why he chooses to use a piece of old sock. He is quick to answer: "Everybody uses a rag; I use this old sock because its ribbed pattern produces a kind of striated effect, a texture that sometimes proves intriguing." Sabater concludes this first stage by alternating sanguine chalk with dark sepia, almost-black chalk, blending with the stump and his fingers, as he begins to model and define the interplay of light and shade. You can see this process in Figs. 235 and 236: above, a preliminary sketch of the drawing in which one can already appreciate Sabater's interpretation of the model's figure and pose; below, a succinct drawing of the shapes and effects of light and shade.

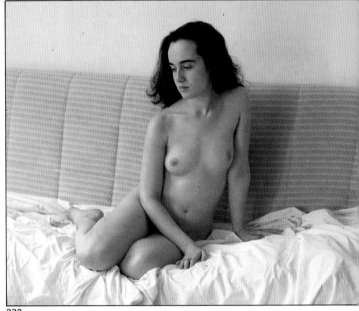

232

233

234

Fig. 232. Here the model is posing, seated on a white sheet spread over a couch, her face turned to one side in a three-quarter position, her body facing the artist, with her thighs foreshortened.

Figs. 233 and 234 Sabater usually draws with the flat edge of the sanguine stick, as we can see from these illustrations, sometimes drawing lines and sometimes creating areas of shade and gradation.

Notice also the wealth of subtlety and color achieved by our guest artist, Joan Sabater, at the end of this first stage of figure drawing using only sanguine and dark sepia chalks.

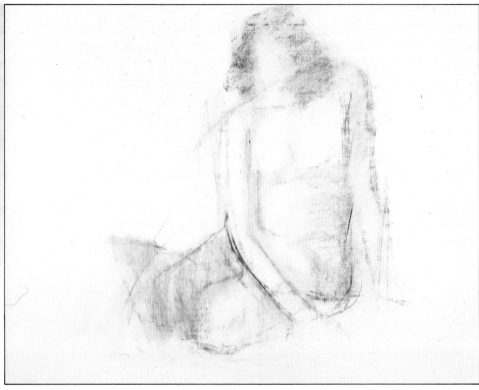

235

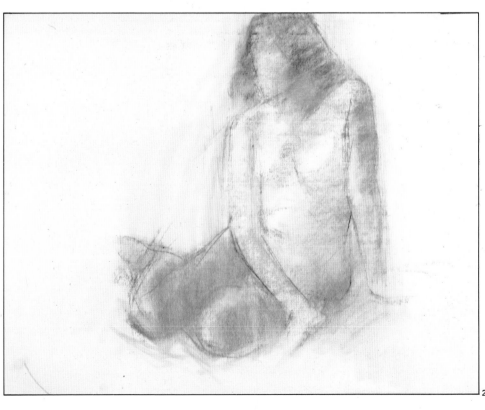

236

Fig. 235. Sabater's initial drawing is very diffuse. Tones predominate, and the shaded areas are achieved by using a stump and by fingertip blending.

Fig. 236. Working gradually, painting rather than drawing, that is, creating form by use of values and defining outline through use of tones, Sabater works steadily to create and recreate the form, which slowly emerges on the drawing paper.

# Stages two and three: color and form

Sabater uses drawing as a preliminary step to painting. He now works more slowly, concentrating harder, spending longer periods studying his model. Slowly, unhurriedly, sometime pausing to look at the model, painting here and there without stopping or lingering for long over any one detail, he first applies pink to various parts of the body. Then he paints over the area around the waist in light yellow using grayish green to paint in the shaded areas of the body and the arms, thereby achieving a sort of luminous reflection in the shadows. Then he fills in the background with black charcoal, sculpting and drawing—modeling— giving definition to the body and the figure as a whole. Then comes the overall blending using the fingers, stump, and the rag, followed by work with the eraser, which he uses to open up light areas and capture reflections on the body and the face. Now, he intensifies some of the shadows, and we begin to glimpse the final result.

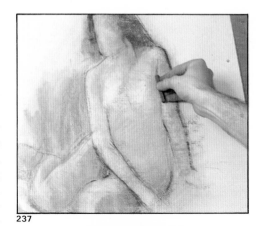

237

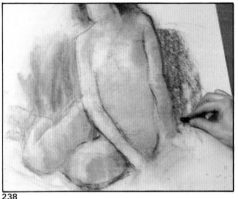

238

Figs. 237 and 238. After working with sanguine mixed with pink, yellow, and light green, Joan Sabater quickly adds definition to the forms by using charcoal to darken the hair and blacken the background.

Fig. 239. This is what the drawing looks like at the end of the second stage. Sabater's use of lines is beginning to distinguish this as a drawing rather than a painting, although form and volume are suggested by color, making this work a painted drawing.

239

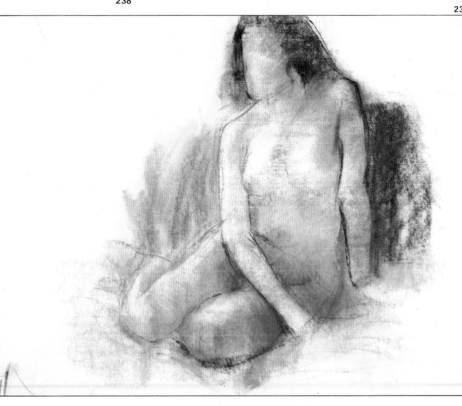

240

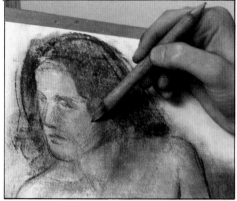
241

Figs. 240 to 243. These illustrations show different stages in Joan Sabater's drawing: blending with the fingers and with a stump, shading and blending on the thighs with a rag, and using an eraser to open up light areas.

Fig. 244. The final version of the drawing begins to appear once the facial features have been sketched in and the reflections on the face, the arm, the breast, and the thighs have been drawn with an eraser.

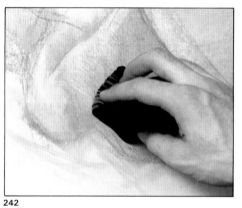
242

243

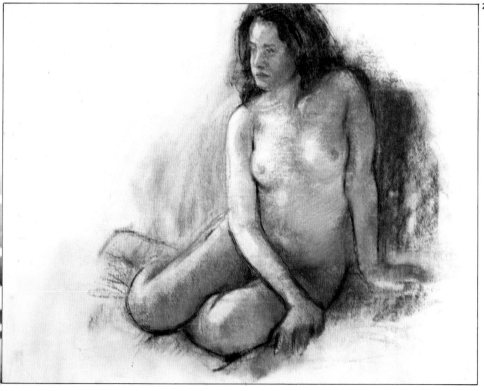
244

# Stage four (the final stage): the finished "painted" drawing

Fig. 245. Here's a detail of the model's head enlarged to its original size to show the quality achieved by Joan Sabater's charcoal, sanguine, and colored chalk drawing. Notice that the withe of the paper is used "as white pigment" and is combined with the colors to produce the flesh tones on the face.

Figs. 246 to 249. Observe in these illustrations the process of drawing and painting used by Joan Sabater to re-create the face of the model; he uses charcoal and a sepia-colored pencil, blending with his fingers and using the eraser to open the light areas.

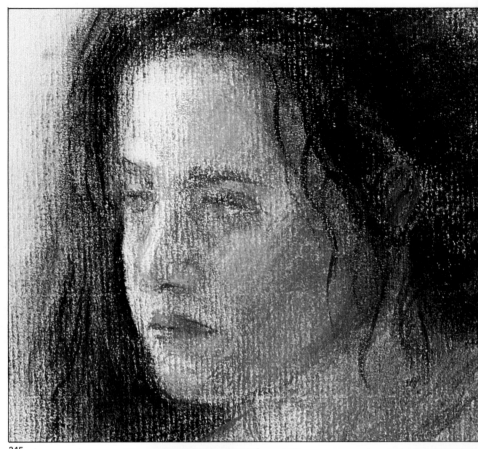

245

Sabater paints the facial features with a dark sepia-colored pencil combined with charcoal, using an eraser to draw the light areas. Sabater defines the shoulders and the collar bone with a pale grayish-mauve chalk. Then he "paints" with charcoal, occasionally combined with red and sepia sanguines as he works on this combined technique "painted drawing."
Sabater used charcoal to sculpt and create contrasts in the drawing, with the emphasis on drawing rather than on painting. Although always trying to strike a balance between the two techniques, the artist looks for the perfect and precise combination that will ensure the color is not overshadowed by the charcoal.

246

247

248

249

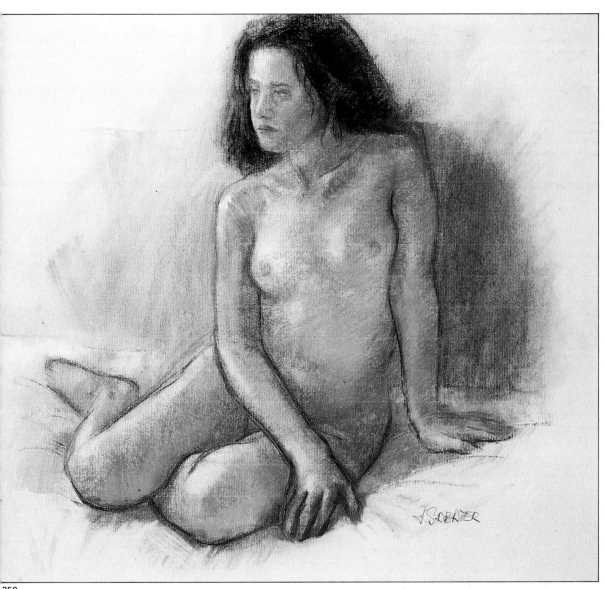

250

In this perfect combination, the basic color, which is the most important element in the picture, is sanguine. The white of the paper, the grain of which is always visible, combined with sanguine and charcoal, produces an optical effect, which is translated into a range of pinks, siennas, ochres, light and dark grays—building a language, the art critics might say. Sabater chooses to elaborate on the pink and flesh tones, which enhance the expressive quality of the picture's color.

These tones may be seen in the life-size enlargement of the head (Fig. 245). This shows the texture and grain of the Ingres paper, which contributes to the optical effect mentioned above. Finally, we can see the finished drawing (Fig. 250) and admire its artistic quality as an example of combined technique by Joan Sabater.

Fig. 250. Here's the final stage of this painted drawing, an example of combined technique by the artist Joan Sabater. The basic colors are sanguine and charcoal, with the addition of pink, pale green, and pale grayish-mauve chalks, resulting in a fine example of combined technique.

# Doing a self-portrait: You are your own model

Fig. 251. Imagine yourself, sitting in front of a mirror that you have put on the wall or rested on an easel. Your drawing board and paper are on your lap, with the other end mounted on an easel or held up by the back of a chair. The light is shining on both your face and the drawing paper, while the pose you have adopted has your body pointed toward the right and your head slightly tilted and turned to the left, looking at the mirror.

Fig. 252. These are the materials used in this portrait: charcoal sticks, a charcoal pencil, chalks (a selection of grays, siennas, and reds), paper stumps, an eraser, and a linen rag.

Fig. 253. Here you can see how far you should be from the mirror and the light. The lamp or spotlight should be on an angle and high enough to shine on both your face and the drawing paper.

251

252

253

A good way to put into practice what you have learned from this book is to draw your self-portrait with charcoal, red chalk, and colored chalks.

All you need for this very valuable exercise is a mirror, good drawing paper of the Canson Mi-Teintes kind, which may be cream, gray-ochre, or light sienna in color, some sticks of charcoal, a charcoal pencil, paper stumps, a kneadable eraser, a rag, and a selection of colored chalks, including a stick of light-blue or pastel chalk. You may like to draw using daylight, but I would recommend artificial lighting with a 100-watt lamp or spotlight positioned so that it shines on both your face and the sheet of paper. Figures 251 and 253 show the approximate height of the light and how you should place yourself in relation to the drawing board and the mirror.

Before we begin, I suggest you make a few rough sketches of slightly different poses, first with charcoal and then with various techniques including charcoal, red chalk, and white highlights. We will, of course, have to refer to the canon we have learned for the human head. My own head is no model of perfection, and it certainly is nothing

# First stage: drawing in charcoal

like the classical canon of the Greeks, but I generally begin by outlining the three and a half vertical modules, the centerline, and so on. I then use the model to determine the dimensions of the ears, the position of the eyes, the mouth, and the other features, making whatever changes are necessary for the likeness to appear.

The illustrations on this page show the advantages of starting the drawing with charcoal, which is easy to manage, easy to erase, and produces good grays and blacks.

Look closely at the pose, the form of the head, and the way the light falls on it. These features correspond to the advice Ingres gave his students with respect to the portrait: "The body

should never follow the movement of the head." That is, as we can see in this example, if the body is pointed toward the right, the face should be looking slightly to the left, in this case straight at the mirror. The light falls on the face from above. But you should take very careful note of how to determine the position and exact height of the lamp or spotlight. As can be seen in Fig. 256, the crucial point is the length of the shadow cast by the nose on the upper lip.

Finally, when I have finished the charcoal drawing, I apply a fixative to preserve its basic structure.

Figs. 254 and 255. I begin my self-portrait by drawing the canon for the human head and then adjusting these basic proportions so the result will be a likeness.

Fig. 256. This is the finished charcoal drawing, showing how the basic shadows are projected. Particular attention should be paid to the shadow cast by the nose on to the upper lip, since the length of this shadow depends on the correct positioning of the lamp or spotlight.

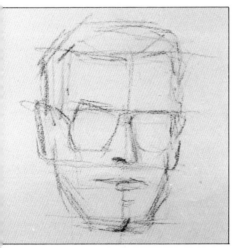

254

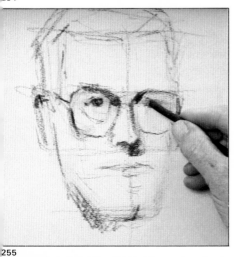

255

256

# Second stage: red chalk, charcoal, and black chalk

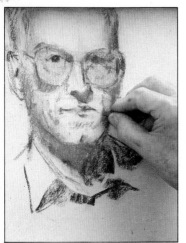

**257**

Figs. 257 and 258. As you can see in these two illustrations, this second stage has been used to strengthen the drawing with a charcoal pencil and black chalk and to add color with the red chalk. The red and the black have been alternated and mixed so that, in combination with the color of the paper, they give a wide range of flesh colors. Finally, I have drawn and painted the hair with black, grays, and white chalk.

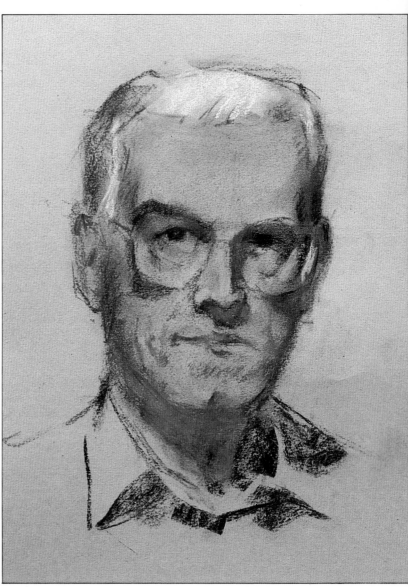

**258**

The second stage basically consists of coloring and reinforcing the drawing. I alternate these two tasks, coloring with red chalk, drawing with a charcoal pencil, and strengthening a few points with black chalk. By drawing in red chalk over charcoal, I mix the two colors to obtain sepia tones that are more or less red, according to the intensity of the red chalk. I then strengthen the drawing and the contrasts with black chalk and the charcoal pencil. In fact, I use the pencil mainly for drawing lines like those of the glasses or between the lips. The black and the red combine with the gray-ochre color of the paper to produce a *dessin à trois crayons,* or a three-colored drawing, based on rather weak, warm tones. The only color to be added is the white of the highlighting, but this will come later. In the meantime, I find myself unable to resist the temptation of coloring the hair—my hair—with white and gray chalk and adding a reflected shine, just one, to one of the lenses of the glasses. Figures 259 to 262 show how to correct

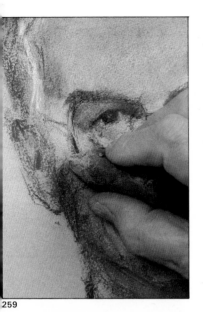

259

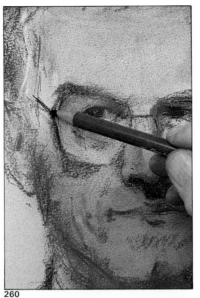

260

261

262

263

a mistake, first by erasing and second by drawing over the mistake with charcoal pencil, shading with the finger, and coloring with red chalk. The possibility of correcting and modifying the drawing shows just how flexible working with charcoal and chalks can be.

Finally, Fig. 263 shows how the nondrawing hand can be used to hold the charcoal pencil, the eraser, and several colors while the drawing hand works on the shading.

Figs. 259 to 262. Here we see how to correct a mistake in form and color, using the eraser, the charcoal pencil, the fingers for shading, and red chalk.

Fig. 263. The need for quick changes between colors, or between the eraser, the stump, the graphite pencil, and so on, makes it useful to keep these items in the nondrawing hand so that they are always ''on hand.''

# Third and final stage: finishing touches

**264**

Fig. 264. At this more advanced stage, the finishing touches are begun with the addition of whites and reflected light, using white or light-colored chalks and an eraser. As can be seen above, I have used the eraser to "open" a white space on the forehead.

Fig. 265. This could well have been the last phase of the self-portrait. I only had to add a few details and several whites and reflections. But I usually let my work "ripen" for a while before completing the final version. So I left the self-portrait as it was and came back to it the next day.

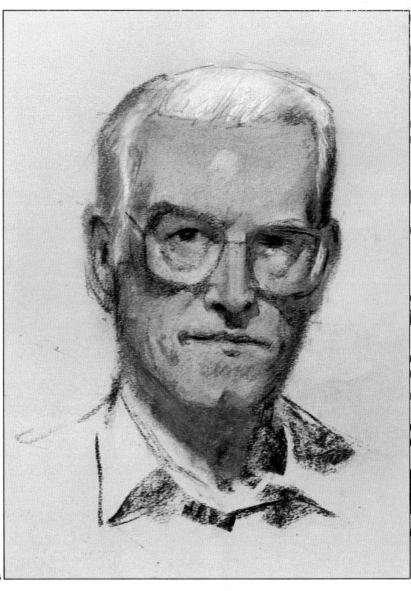

265

One piece of advice that I often find myself repeating is that no drawing or painting should be completed in just one session. It is possible to do so, but not advisable. When you leave the work for a while, you are able to clear your head and see with fresh eyes.

With this particular self-portrait I spent quite some time doing the finishing touches, refining the drawing, the intensity and tonality of the colors. I even added a few touches of yellow ochre and sepia. But when I decided to begin the serious finishing, drawing the reflections and the whites (I even used the eraser to "open" a reflection on the forehead), there came a moment when I knew it would be better to leave the very last touches overnight, *"hasta mañana."* The next day I looked at the portrait in a mirror—a perfect trick for telling what is right and what is wrong—and decided to make a series of corrections. I changed the way the hair comes on to the forehead, corrected the upper-right part of the hair, slightly altered the mouth, and the point of the chin. Then I finished, adding the whites, highlighting the reflections, and putting in the blue of the shirt. I was really having a good time!

I have said all I have to say. I hope you too will enjoy the art of drawing portraits.

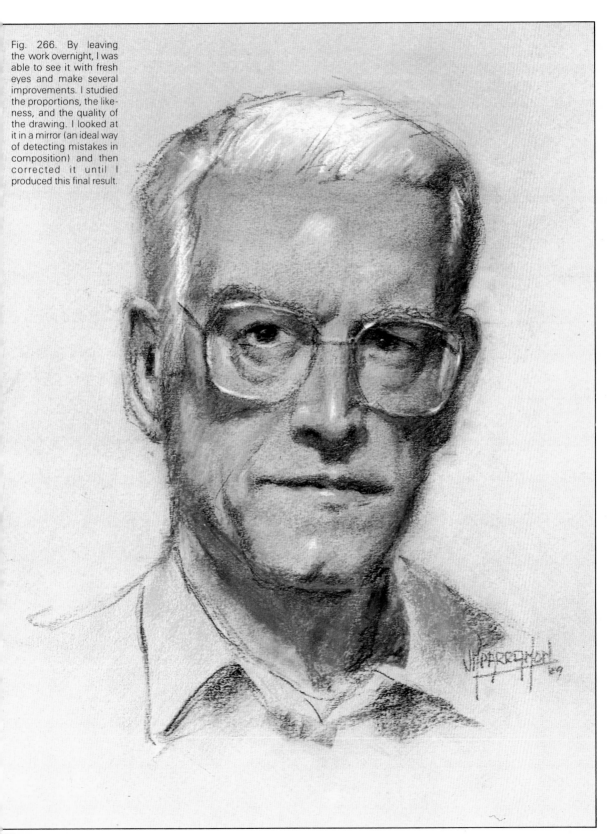

Fig. 266. By leaving the work overnight, I was able to see it with fresh eyes and make several improvements. I studied the proportions, the likeness, and the quality of the drawing. I looked at it in a mirror (an ideal way of detecting mistakes in composition) and then corrected it until I produced this final result.

# Model of the half mask of Beethoven

Use this model for the exercise described
on pages 56 to 67.
Remove this page from the book, and
follow the instructions concerning the
position, distance, and lighting of the
model. Then you can begin this exercise
in charcoal pencil drawing.
Believe me, you will find it an extremely
useful exercise.

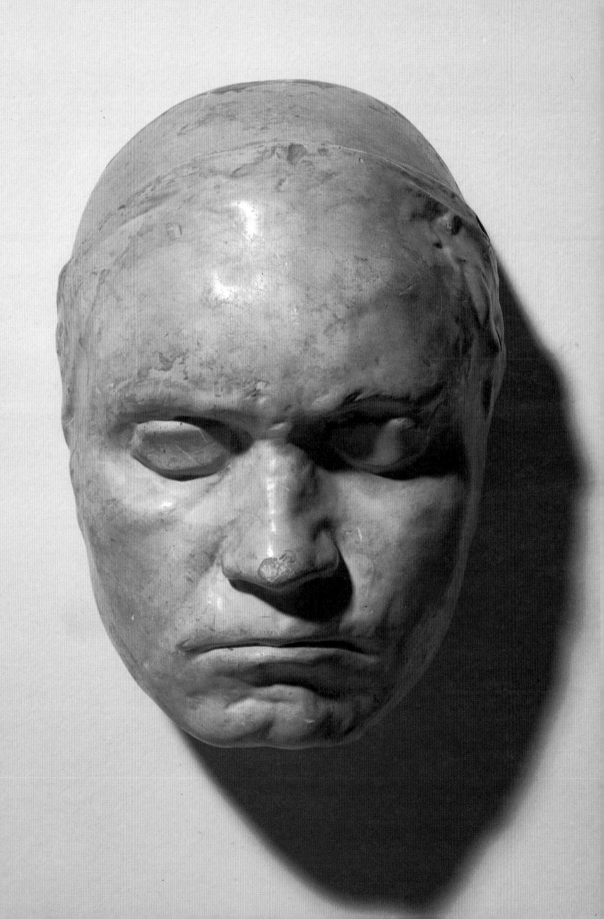

# Model of a still life

Use this model for the combined technique exercise described on pages 89 to 93. Remove this page from the book—or compose your own model. Be sure to follow the instructions for lighting and preparation of your materials.
For this exercise you will need charcoal, charcoal pencil—or black chalk—and colored chalks. Perhaps, after drawing this still life, you will decide to try out the other possibilities of combined technique.

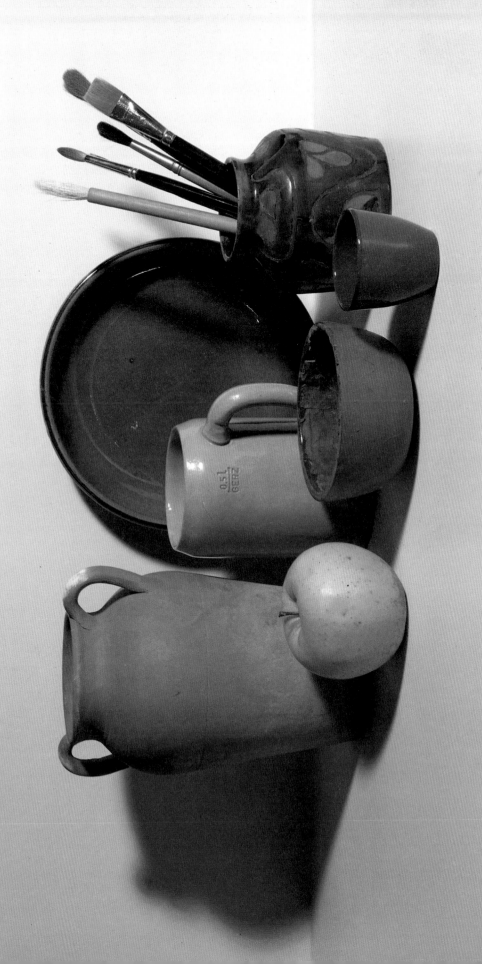

*The author would like to express his thanks to Miguel Ferrón for his contribution to this book and for his design of the book's layout, as well as for drawing one of the exercises; to Jordi Segú, who provided a number of illustrations; to Joan Sabater, the author of one of the exercises in combined technique; to the photographer, Sigfrido Romañach; and to Vicente Piera for his advice on materials.*